ABANDONED
EASTERN OHIO

ABANDONED EASTERN OHIO

TRACES OF FADING HISTORY

*Barbara + Allan,
Come back so
you can see these
places.
— Peggy*

CINDY VASKO

AMERICA
THROUGH TIME®
ADDING COLOR TO AMERICAN HISTORY

I dedicate this book to the manufacturing workers of the United States—America's backbone. I hope this workforce continues to cling to the American Dream, despite the economic assaults and challenges they confronted for more than forty years. History cannot be pardoned, but society is nevertheless onward, and dreams are more powerful when joined with others. After all, a dream, such as the American Dream, has always been a bit short of full realization for any generation, so it is still a possibility worthy of pursuit.

America Through Time is an imprint of Fonthill Media LLC
www.through-time.com
office@through-time.com

Published by Arcadia Publishing by arrangement with Fonthill Media LLC
For all general information, please contact Arcadia Publishing:
Telephone: 843-853-2070
Fax: 843-853-0044
E-mail: sales@arcadiapublishing.com
For customer service and orders:
Toll-Free 1-888-313-2665

www.arcadiapublishing.com

First published 2021

ISBN 978-1-63499-312-8

Typeset in Trade Gothic 10pt on 15pt
Printed and bound in England

CONTENTS

INTRODUCTION

Are the principles associated with novelist Horatio Alger, Jr.'s protagonists losing their resonance? The American dream—the ideal—is the notion that hard work, virtue, determination, and courage would bring forth rewards, akin to Alger's rags to riches stories, or, more simply, the stable comforts of hearth and home. For so many in America's manufacturing belt, such as those from eastern Ohio, the American dream is increasingly losing luster and seems unreachable for too many. In America's manufacturing belt, a community song of unrelenting partings is often the substitute for the elusive American dream—farewell to neighbors and friends, farewell to a robust standard of living, farewell to cherished sacred places and schools, farewell to a culture, and farewell to a home. For more than forty years, the eviction of opportunity and unraveling economic constancy are the unwelcome squatters within the manufacturing belt.

Shy of one week of the fortieth anniversary of Ohio's Black Monday, the devastating September 19, 1977 event that pink-slipped 5,000 Youngstown Sheet and Tube steelworkers, and unleashed a chain reaction of further Ohio steel and manufacturing closings that eventually uprooted an additional 50,000, former White House strategist Steve Bannon opined about economic nationalism during a televised CBS *60 Minutes* interview. Economic nationalism, the hypothesis that the entirety of the United States is locked in a zero-sum economic race with other nations or that Americans can become wealthier at the expense of non-nationals, is fantasy, in the eyes of this former graduate student of political economics, but I digress. Economic nationalists believe that a country's economy is enhanced if its industrial base tightly grips sovereignty and enforces border control. The Bannon formula is a mishmash of trade protectionism and aggressive unilateralism—two of several attributes that

pushed the manufacturing belt into troubled waters in the first instance. Bannon's interview even invoked the name of two northeast Ohio Democrats, Sherrod Brown and Tim Ryan, and claimed while these two might not agree with his view, they understand his economic vision for the United States. Understanding, however, does not mean consensus. Bannon believes the chaotic deindustrialization of the last five decades will have traditional party affiliations engaging in a political brawl with conservative and liberal populist movements, each side promising, and typical of too many politicians' rhetoric, a genuine positive change for the working people of America. Is Bannon's perception just a fancier explanation for class war, and whoever promises most wins? Actually, much of Bannon's vision of resentment politics is very much alive and well due to decades of manufacturing belt economic loss. The politics of resentment and the promise of manufacturing's return to America's manufacturing belt regions are two reasons Donald J. Trump slid into the White House, notwithstanding Bannon's concept. Will the same acuities apply to the election of 2020? Since this book was written before the general election of 2020 and will release well after the election, the industrial regions of eastern Ohio, no doubt, will have a direct hand in the presidential outcome; so what flank will these wounded citizens select in 2020?

Ohio holds a fertile landscape of natural resources, low-cost energy, and ample transportation facilities that transformed Ohio into a great industrial state. Coal, oil, natural gas, clay, salt, limestone, sandstone, gypsum, and shales aided local industries and fomented prosperity. A good portion of the raw materials processed in Ohio's industrial works derives from the state's resources. A substantial slice of the labor force is employed in manufacturing, albeit positioned within an industrial production decline since the 1970s.

The eastern portion of Ohio is similar to my childhood city, Allentown, Pennsylvania. Allentown was noted for steel, manufacturing, steel, roaring 1950–60s prosperity, steel, progressive education, steel. Yes, steel was always the engine of growth for this region, as it was for eastern Ohio. So many analysts discourse about the collapse of America's heavy manufacturing sectors, and an abundance of familiar arguments join the industrial collapse stew—automation, lack of innovation, labor disputes, leadership voids, shortsighted plans, and the word *du jour*, globalization—the antithesis of economic nationalism. Many of these variables have a finger, if not a full hand, in the latter part of the twentieth century's industrial demise.

The completion of this book dredged up so many memories of my childhood. I grew up in a dynamic era and witnessed a vibrant industrial base coming to an end during the 1970–90s. Initially, industry's ending seemed to move slowly. All of a sudden, though, the descent moved at a seemingly exponential speed

without allowing a respite to contemplate the fragmentation of the once-powerful United States industrial engine. Engines operate until they break down and incur replacement by new, more efficient, technologically superior engines. The industrial engine was erected with cogs of supply chains, unions, management, commodity prices, sunk costs, and here is that word again, globalization. The problem with this assembly is that a vital portion of the engine's cogs were people. People should not be considered obsolescent or disposable by new, more efficient models—or should they? Human cogs were replaced by mechanical cogs in so many cases—such irony is embedded in reality. Automation, not trade that Trump roars about since 2016, seems to be a significant displacing element for manufacturing's declining employment levels. Robotics allow manufacturers to create more output with fewer human cogs, and this robotic trend is growing and seeping into all profit-generating engines, not just industrial engines.

In a cycle persisting for more than forty years and counting, the manufacturing belt engine's collapse was marked by strikes, layoffs, unemployment, poverty, and homelessness. The consequence of this breakdown is economic displacement, outmigration, and, of course, abandonment—abandonment on a massive, over-whelming scale. Witnessing ruins of rusting manufacturing facilities that once boomed, generated stability and contentment for an industrial community is a painful landscape. Making sense of this finality is still very problematic because the great economic unfolding continues to loom over manufacturing belt regions and this begs the question: is the beating heart of hope still alive? Will hope continue to be the lifeline for the arrival of something better emerging from the industrial ruins? In 2016, the manufacturing belt regions believed Trump would deliver "better" to their decaying industrialized turf and in turn, placed their voting faith in him. After four years, though, is there anything palpable to show for these promises?

In 2016, Trump spoke directly to the once-powerful manufacturing belt citizens when he pledged to strengthen the United States economy and revive domestic manufacturing in places where industry and employment vanished. According to Trump, steel and coal were the core industries for a revived United States economy. The reality is that manufacturing in 2020 is still on a flight path out of eastern Ohio. Unemployment levels are commensurate with the 2008 Great Recession and actually worse with the COVID-19 pandemic onset. In March 2019, the vast General Motors production facility and community economic driver for a large eastern Ohio community shuttered its Lordstown operations after fifty-two years in business and producing more than 16 million vehicles. Lordstown employed about 4,500 workers when Trump first stepped foot in the oval office. Trump's 2016 campaign broadcasted job security for Lordstown's workers—the area's largest

private-sector employer. Trump asserted, "don't move, don't sell your house." Now, will the Lordstown residents have to sell their homes, or worse, abandon them like so many have done in eastern Ohio's Mahoning Valley?

Similarly, in October 2019, Murray Energy, a prominent Ohio coal mining enterprise with close ties to Trump, filed for bankruptcy and sent shockwaves throughout the working communities of Ohio, West Virginia, and Kentucky. It does not appear that a steel and coal revival was ever feasible for Ohio's hard-working people, contrary to the 2016 presidential candidate assurances. Additionally, for every General Motors or Murray Energy-sized ending, numerous smaller-scale layoffs are being pulled into the wake of an industrial giant's dissolution.

History is cyclical. History is not a linear march toward utopia or dystopia. History presents cycles of relative peace, prosperity, and stability, and other times of comparable strife, economic upheaval, uncertainty, and instability. I think the United States is still navigating the turbulent 1970s economic waters. Large bands of the manufacturing belt stagnated and continue to languish for decades resulting in unrecovered job losses nearing 50 percent over the past five decades. Democrats and Republicans do not have to agree on everything, and they certainly do not. Still, they should surely agree that many citizens in the United States' industrial regions are struggling. Both parties have a stake in helping this region, and any promises must be absent hollow rhetoric. The government must cease viewing these economically bruised areas like Generation X-ers struggling to find their place in society. Unfortunately, politicians do not have a handle on resolving these life and death issues for manufacturing belt residents, at least not within the past four years. Promising rewards and not seeing returns fuels the resentment and pushes the narrative further into Bannon's extreme economic nationalism paradigm. The year 2020 propelled so much political bitterness and class war-esqueness to the national scene on more levels than one. Of course, the solution to these dilemmas requires no less than a colossal bipartisan undertaking with such analysis and discussion best obliged for another book. Since my publisher limits my word count, I am unable to advance a conversation about such solutions. The above issues, though, lead into my book's presentation of multi-layered economic dismantlement following deindustrialization: the abandonments of business, services, homes—the loss of an industrial community's collective soul. At the base, we need to view our country with new eyes and vision—and move away from the great divide that plagues us. We need to recognize that citizens hurt for many reasons. To see the heart of a family—the home—left to nature's elements, and personal artifacts of happier times left behind is not something America should embrace. All Americans should be able to hug a Horatio Alger scenario and run with it. Each abandonment

represents the death of hope and dreams, and we should not look away when we see one, two, hundreds, or thousands of failed American dreams.

Abandoned Eastern Ohio consists of five chapters—three chapters reveal the direct consequences of the opposing economic forces set in motion on Mahoning Valley's fateful day of Black Monday—the flip of the lever for big steel's denouement. Iron Soup, a community erected by Youngstown Sheet and Tube for its labor force, exposes the shattered dreams of families that once served a mighty steel mill. The Gateway Rail Yard, once accommodating the Pittsburgh & Lake Erie rail line, known as the Little Giant, is now a rusting shell and a constant landscape reminder of the region's former power. A derelict church and school complex, once a sanctuary for those needing sacred refreshment or a safe place for socializing, now rots away in a quiet neighborhood. Not all abandonments, though, have despondent endings. A group of activists saved the Variety Theatre in Cleveland. This once-lavish movie palace shouted for a rescue of its decaying beauty, and its silent scream was heard and is undergoing restoration to be the neighborhood jewel once again. Finally, while the Ohio State Reformatory appears to be somewhat located in the middle of the state, the site's geographical description noted its location as northeastern Ohio, and accordingly, I included it in this compilation. This marvelous piece of architecture narrowly escaped the wrecking ball and has a new, prosperous life. In true Hollywood fashion, the movie industry saved the site from demolition and inadvertently gifted hope with rewards to its community, which also suffered greatly from industrial divestiture. Regarding the Reformatory, the concept of hope intertwined curiously and acted as a saving grace and bequeathed a moral lesson for all to seize. Hope is the spirit of life. Hope keeps our eyes open for an enriched future and helps us overlook the sufferings of the present. Maybe there is, after all, a little Horatio Alger still embedded within the eastern Ohio soil, as well as in our souls.

I think the manufacturing belt citizens cleaved to hope for decades, and their reward for things so many Americans take for granted is long overdue. I do not know if such hope strongly prevails in 2020, or will remain afterward. Hope, however, usually never falls on a negative plane, so it still might be salvageable within the heap of industrial detritus. Simplistic as it is, hope can corral shared power and collective action for transformation, rooted in grief and rage, but directed toward vision and dreams—even the American dream. Through political realignment or community engagement, such collective action can be transformative as long as the past is bathed in sunlight, not couched in hollow political bombast while holding on to hope as the engine for change.

1

THE POWER OF HOPE

Hope is a good thing, maybe the best of things, and no good thing ever dies.

Andy Dufresne
Character in film, *Shawshank Redemption*

Ohio State Reformatory ("Reformatory") in Mansfield, Ohio, was Hollywood's "chosen one." The Reformatory was the cinematic set for a transformative movie—a movie with a theme that created visceral emotional tides among the world masses and unwittingly hurled a lifeline to Mansfield. The Reformatory, however, was not just a Hollywood set; it is a vessel that forever holds the spirits of human grief and pain of those that once called this stone fortress home. The Reformatory, nevertheless, eventually assumed the role of an accidental savior on many levels. Hope—an overriding theme of the movie *Shawshank Redemption* ("Shawshank"), and filmed on the Reformatory grounds, served as a needed respite for the people of Mansfield reeling from deindustrialization afflicting its region.

Mansfield, about halfway between Columbus and Cleveland, and like so many manufacturing belt cities, fell on hard times. Once a flourishing industrial center, Mansfield's former thriving manufacturing plants of Westinghouse, Tappan Stove Company, Ohio Brass, Armco Steel, Mansfield Tire and Rubber, and a recent casualty, the local General Motors plant, shuttered operations with the demise of America's heavy manufacturing epoch. These plant closures battered a city of fewer than 50,000. So much was lost. It is always challenging to hang on to hope when familiar lifestyles and routines collapse. The Reformatory closed too and contributed to reductions in workforce and revenue. Still, the Reformatory eventually embarked

on a road less taken that proffered an unexpected gift for the Mansfield community.

My visit to the Reformatory happened on a sunny, early spring day. I prearranged special access to prison areas not called on by the general public. A good friend accompanied me to the Reformatory, and I was excited to commence with the composition of digital images of this imposing fortress. I was instantly taken aback by the site's massiveness as I entered the long driveway bordered by manicured lawns and berms. The Reformatory is a combination of Victorian, Gothic, Richardson Romanesque, and Queen Ann architectural styles. The prison seemed more like a European Castle than former housing for some of America's most hard-edged offenders. Still, an ominous aura seemed to loom over the structure, with its massive, bumpy sandstone blocks, aged copper bands of flashing, pale green shingled roofs, arched wing windows, inviting porches, striking central tower and turrets—not typical American architecture. To my eye, the Gothic and Victorian characteristics stood out and were intimidating—simultaneously romantic and dark. The mysteriousness of Gothic style combined with the charming Victorian features presented a Brothers Grimm aura—like an attractive oversized dwelling holding insidious intentions to trap Hansel and Gretel. Was the interior of this shadowy, yet striking structure just as interesting and alluring as its façade?

Once I parked and exited my car, a persistent and angry goose ran toward me and my friend—a guard goose, I suppose. This feathered guy was so irritated with our presence and would not let us pass. We had to use our tripods as a shield from potentially painful pecks as well as holding the line on the goose's cantankerous honking and hissing. Once we saw a narrow path for escape, we dashed to the Reformatory entrance. We were indeed a bit smug after conquering a successful getaway on prison soil—albeit from a goose.

Once inside the Reformatory, adornments were of a massive magnitude—cavernous rooms with high walls, intricate scrolled wrought ironwork, wide hallways, repetitive tall wooden columns, and light fixtures suspended on long cords. Nothing prepared one, though, for the astonishment of seeing the world's largest free-standing six-tiered steel cell block. The east cell block holds approximately 600 7-foot by 9-foot lockups. Each chamber held two inmates in a small iron cage. The streaming sunlight through narrow, barred window cavities, in addition to the illuminated incandescent pendant lights, cast a carroty ethereal wash throughout the cell block. Paint peeled from the symmetrical bars and prison bunks presented the advanced stages of rust. The decayed appearance of the Reformatory interior is, of course, to my liking. The flaking paint and deteriorating stucco walls are everywhere. Still, the facility's strong bones stand proud and seem to shrug off any demand for restoration of its crumbling surface layer of "makeup." The Reformatory in a word is daunting.

The Reformatory was built in 1886, but after a century of prison operations, the Reformatory locked its iron doors and gates on the last day of 1990, courtesy of a court order that included a list citing deplorable prison living conditions. The Reformatory employed many in the Mansfield area, so when this site joined the manufacturers' closing cavalcade, Mansfield's hurt deepened, and a bit more community hope vanished. The magnificent architecture of the Reformatory was slated for imminent demolition. Hollywood, though, called at the very last saving minute, and in short order, moviedom was onsite at the Reformatory and undertaking the production of the film, *Shawshank Redemption*.

When *Shawshank Redemption* opened in theaters in 1994, movie audiences' receptions were lackadaisical even though the film garnered seven Oscar nominations. Home video and cable showings of *Shawshank*, nevertheless, created a ground-swelling fan following for the movie, and in turn, the birth of *Shawshank* pilgrims. The *Shawshank* fans unfailingly gripped inspiration from the film's message of friendship and, most importantly, the power of hope. *Shawshank* fans from all over the world traveled to the Reformatory to soak in the mere sight of the film's setting. Mansfield realized this growing storm of fan interest and smartly marketed the Reformatory's *Shawshank* message by opening the Reformatory for public tours. The Reformatory's new mission of inspiration brought forth needed revenues for a city suffering economically and delivered a bonus layer of community pride.

Tough times happen to all of us—even to cities and towns. Tough times envelope us and attempt to crush us no matter how confident we are. As assured as we can feel one day, we can feel just as adrift and frightened on another day. The most challenging aspect of rough periods is to maintain a sense of hope. *Shawshank* is a captivating lesson about the imprisonment of the body and the incarceration of the spirit. The *Shawshank* movie presents a man wrongly sentenced for a double homicide, enduring countless assaults, yet still struggling and persevering to keep hope alive. Hope is life-changing magic, but magic often does not happen instantaneously. The message of hope in *Shawshank* transferred to the people of Mansfield, along with the magic of economic reward. Thanks to the *Shawshank* pilgrims, the town's fortunes rose. Between 2013 and 2018, more than 600,000 visitors worldwide and across the United States journeyed to the Reformatory. Tourism draws $13 million annually to this area.

While *Shawshank* is a timeless story of hope turning adversity into triumph, this scripted Hollywood message of hope reached beyond the movie theater and brought a new life to Mansfield. Hope is indeed a good thing, and like *Shawshank*'s moral lesson, good things do not die. As for the conclusion of my photographic walkabout within the walls of this imposing site, I merely hoped to get to my car without having

to re-battle a cantankerous goose. I was tired from slogging heavy camera gear along many interior miles and was not in the mood for feathered drama. As I exited the Reformatory, I saw Mr. Cranky sitting next to another goose on a nest near my car. I realized Mr. Cranky was merely protecting his lady and their future offspring during our morning encounter, and I suppose his late afternoon silence and stillness was due to his exhaustion after a long day of active guard duty. I hoped for an uneventful walk to my car and happily embraced my quiet gift—yes, hope is magic.

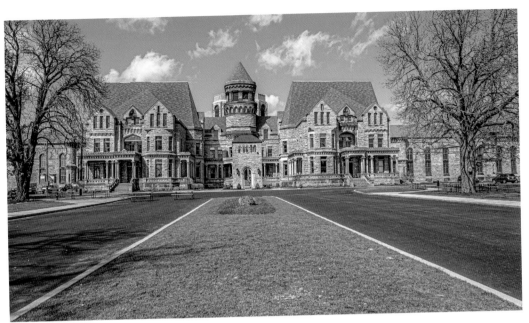

OHIO STATE REFORMATORY, MANSFIELD, OHIO: Ohio State Reformatory ("Reformatory") is a combination of architectural styles: Victorian, Gothic, Richardson Romanesque, and Queen Anne.

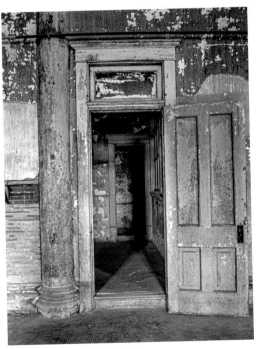

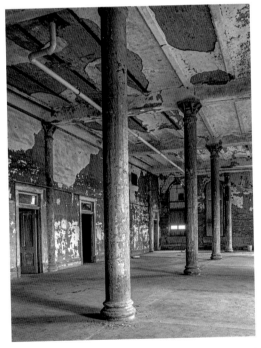

◀ **ADMINISTRATIVE OFFICE AREA:** The prison cornerstone was laid in 1886, and the Reformatory's original intentions were directed toward the rehabilitation of young offenders. Even though the Reformatory opened in 1896, the prison was not completed until 1919.

▶ **ADMINISTRATIVE OFFICE AREA:** Several movies were filmed at the Reformatory, including *Shawshank Redemption*, *Air Force One*, *The Wind is Watching*, *Tango and Cash*, and *Harry and Walter Go to New York*.

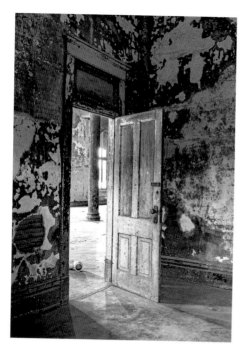

▲ **ADMINISTRATIVE OFFICE AREA:**
The Reformatory was abandoned in 1990
and the cellblocks and administrative areas
are in a state of arrested decay.

▼ **CELLBLOCK:** The message of hope inherent
in the movie *Shawshank Redemption*
inspires many from all over the world to
embark on pilgrimages to the Reformatory.

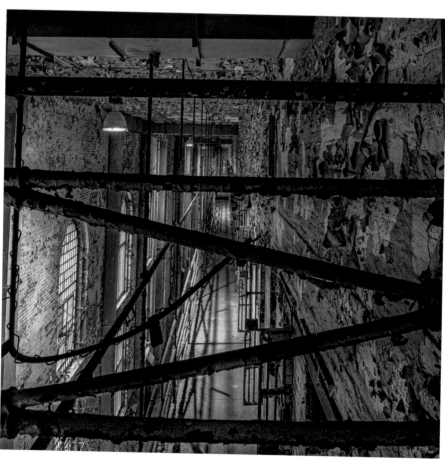

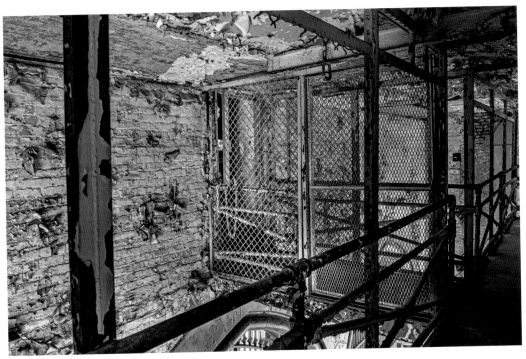

CELLBLOCK WITH CAGE ACCESS TO CHAPEL: *Shawshank* pilgrims visit the Reformatory because of inspiration—they are not calling on a place, but grasping an idea, and that idea is hope.

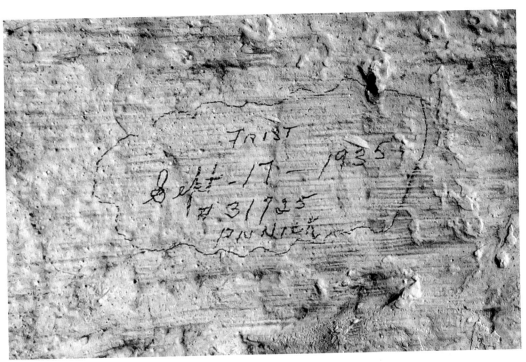

1935 PRISONER GRAFFITI/INSCRIPTION ON WALL OF ATTIC ROOM: The Attic Room is where overflow prisoners were temporarily quartered. The attic area is absent of light, and has poor ventilation. Many inmate inscriptions are etched into the walls.

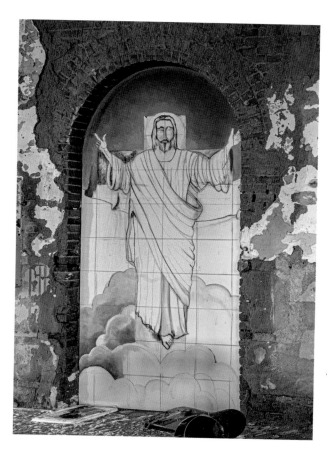

▲ **JESUS ROOM:** Before the establishment of the Reformatory's larger chapel, this area held the chapel, and it is also known as the Jesus Room, because of this large mural.

▼ **JESUS ROOM:** A *Shawshank* message is that true faith will be rewarded, and that life's environments do not define a person.

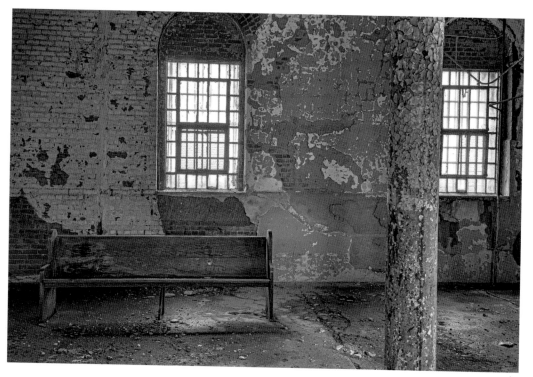

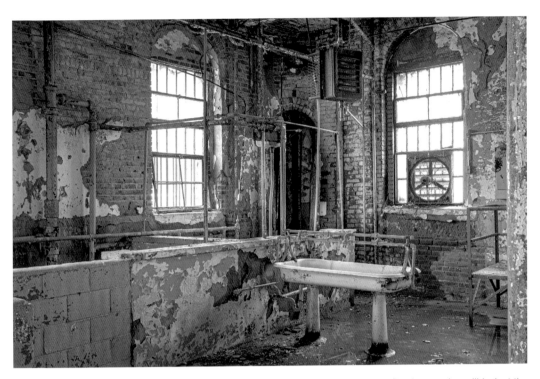

WASHING AREA SHARED WITH JESUS ROOM: In the 1930s, a devastating fire destroyed a cellblock at the nearby maximum-security Ohio State Penitentiary. About 300 hardened prisoners transferred to the Reformatory at this time.

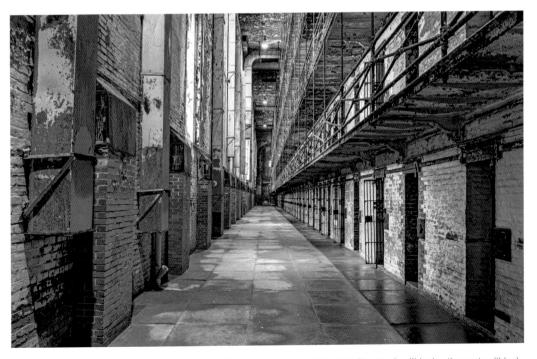

EAST CELLBLOCK: The Reformatory holds the world's tallest free-standing steel cellblock—the east cellblock. This cellblock holds six tiers, with 600 cells for 1,200 prisoners.

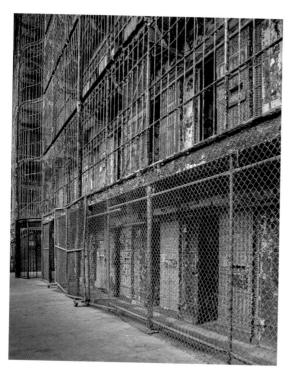

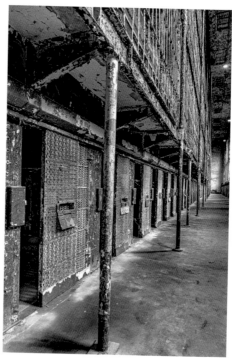

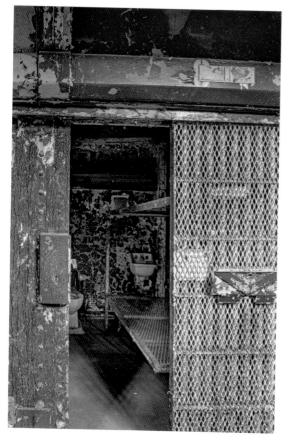

▲ **WEST CELLBLOCK:** The prison guards referred to the Reformatory as "the Castle." The architect of the Reformatory wanted the exterior to resemble an old-world German cathedral with turrets and towers.

▲ **WEST CELLBLOCK:** The original intention of the Reformatory was not to be a maximum-security facility. The Reformatory was designed to be an intermediate prison—for first-time offenders, especially those too old for the juvenile hall but too young for the state penitentiary. By the 1970s, though, the Reformatory, for all intents and purposes, was a maximum-security prison.

▼ **CELL WITH METAL BUNKS:** In 1948, two inmates were released early for good behavior, but then murdered a tavern owner in nearby Columbus. After this, the inmates returned to the Reformatory to inflict revenge on the warden.

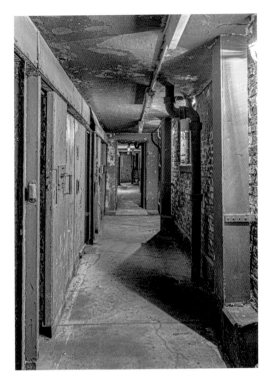

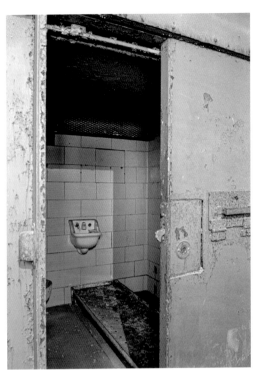

◄ **SOLITARY CONFINEMENT CELLBLOCK:** When the returning parolees, noted above, could not find the warden, they kidnapped the prison farm superintendent, his wife, and the couple's twenty-year-old daughter.

► **SOLITARY CONFINEMENT CELL:** The returning parolees took the farm superintendent, his wife, and daughter into a cornfield and murdered them. The parolees were named the Mad Dog Killers.

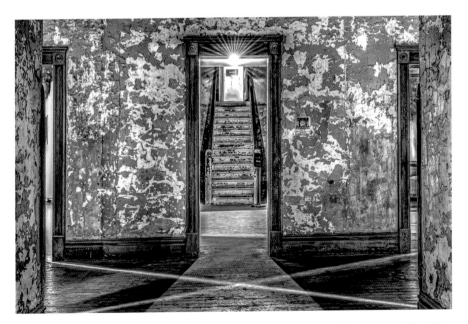

WARDEN/SUPERINTENDENT LIVING AREA AND STAIRCASE TO CHAPEL: One of the Mad Dog Killers was killed in a shootout with the police. The other Mad Dog Killer was executed for murder.

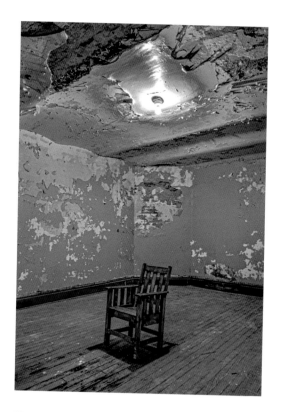

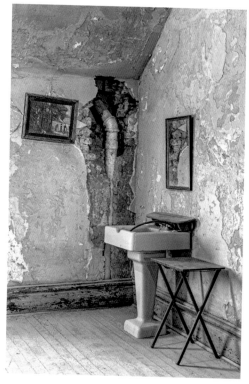

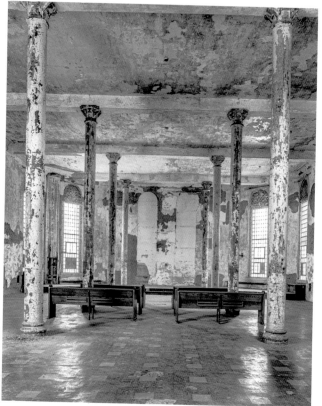

▲ **WARDEN/SUPERINTENDENT LIVING AREA:** Except for the Mad Dog Killers incident, the Reformatory's history of violence, when compared to other prisons, is quite tempered.

▲ **WARDEN/SUPERINTENDENT LIVING AREA:** The Reformatory escaped rioting incidents—characteristic of many other prisons. The Reformatory does not have an execution chamber.

▼ **CHAPEL:** According to ghost hunters, the chapel is one of the most active areas in the Reformatory with regard to paranormal activity. The chapel is considered a central point for the hauntings.

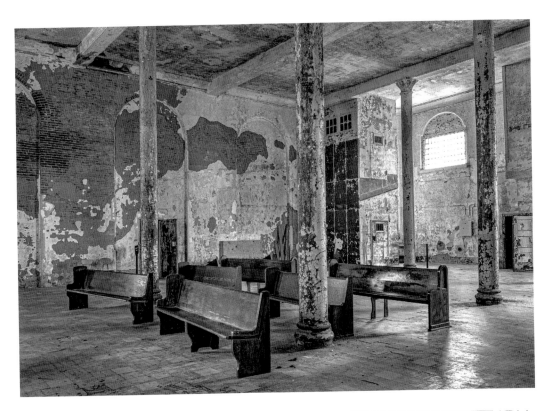

▲ **CHAPEL:** Allan Coe of "Take This Job and Shove It" music fame, was the most famous celebrity prisoner.

▼ **CHAPEL:** In addition to movie productions, the Reformatory adds to its list a host of other media tapings, such as *Ghost Hunters*, *Ghost Adventures*, *Paranormal Challenge*, *Most Terrifying Places in America*, *Scariest Places on Earth*, and *Ghost Hunters Academy*.

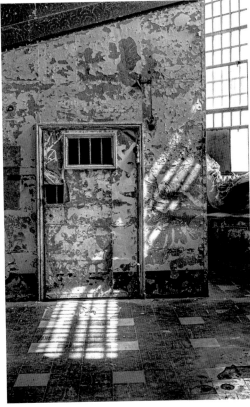

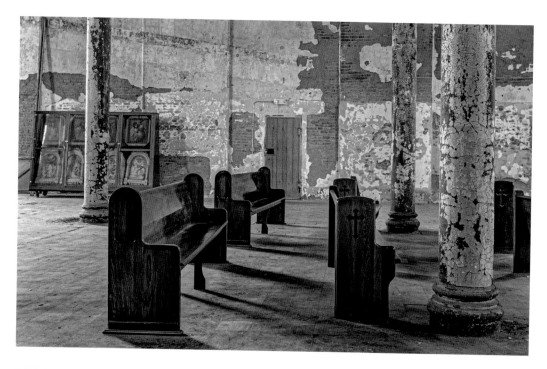

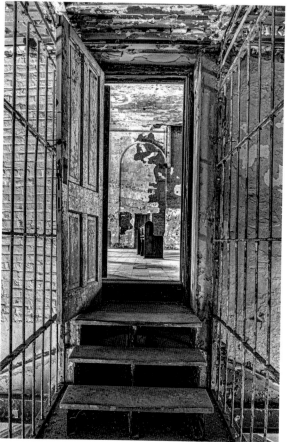

▲ **CHAPEL:** The Reformatory hosts sixteen annual overnight ghost hunts.

▼ **CELLBLOCK ENTRANCE TO CHAPEL:** Even though executions were never on the agenda at the Reformatory, several died within the Reformatory, with some falling over the cellblock tier railings.

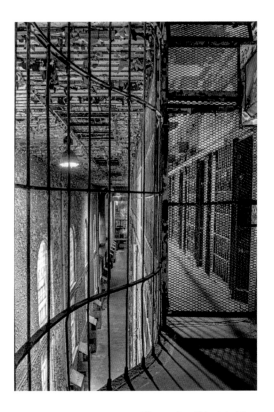

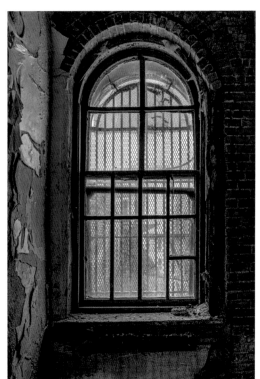

▲ **WEST CELLBLOCK:** The west cellblock held slightly larger cells and, thus, was called The Hilton. The east cellblock, with its smaller cells, was known as Motel 6.

▲ **CELLBLOCK WINDOW:** Architect Levi T. Scott designed the Reformatory and gleaned vison from German castles and the sixteenth-century French Château de Chambord.

▼ **WEST CELLBLOCK:** Unlike the east cellblock, the west cellblock holds fence-like lattices in front of the cell walkways—to prevent falls from upper-tiers.

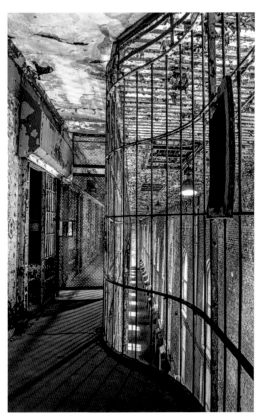

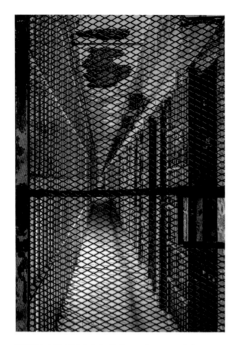 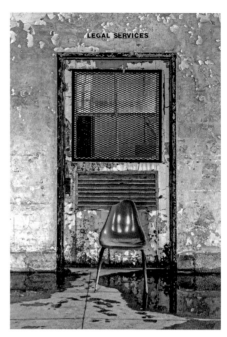

◄ **WEST CELLBLOCK:** Reformatory punishment escalated over the decades, and some punishments included water hosing, sweatboxes reserved for non-Caucasian inmates, electro-torture, and the infamous Hole—a small solitary confinement cell with a typical stay of three days, absent of light and 95-degree temperatures.

► **LEGAL SERVICES OFFICE:** A lawsuit citing brutal and inhumane Reformatory practices was filed by the Council for Human Dignity in 1978. Per a 1986 federal court order, the Reformatory was to close, with a closure date extended to 1990 due to construction delays for the adjacent Mansfield Correction Institute.

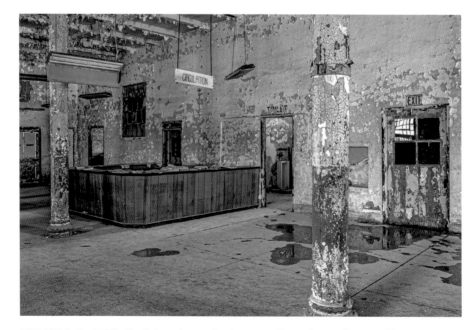

LIBRARY: In the 1930s, the Reformatory realized overcrowding and unsanitary conditions.

LIBRARY LEFTOVERS: The first 150 inmates entered the Reformatory in 1896, and because much of the prison was unfinished, the new inmates were assigned as laborers for completion of the Reformatory.

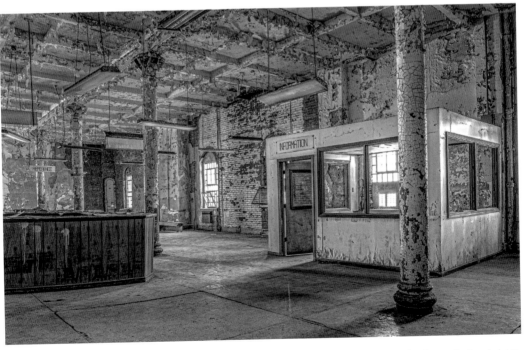

LIBRARY: The Reformatory had a trade school in its early days of operations. The school manufactured shoes, furniture, vehicles, harnesses, and tools. Today, inmates from the adjacent Mansfield Correctional Institution perform grounds-keeping and landscape services on the Reformatory site.

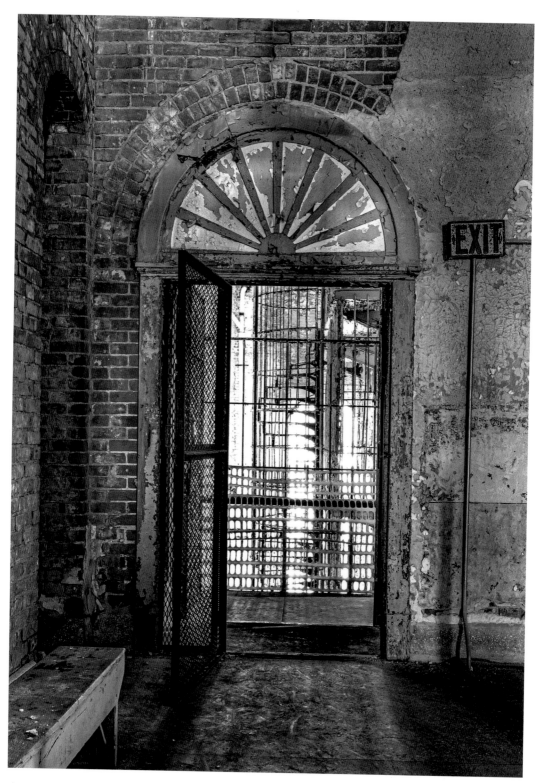

ENTRANCE TO CELLBLOCK: The Reformatory was abandoned and destined for demolition in 1990, but Hollywood stepped in just before a tear-down and submitted its proposal to film an on-site movie.

2

BRINGING DOWN THE HOUSE–LITERALLY

For almost sixty years, Cleveland's beautiful Spanish Gothic Variety Theatre served the community with vaudeville shows, movies, and musical performances. Opulent in the movie palace style, Variety cried uncle when the rock band Motörhead played a gig at the theatre in December 1984. With a Motörhead performance at an ear-splitting and mortar fracturing decibel level, Variety's ceiling cracked and had plaster showering down on the concert attendees. Measuring beyond the "threshold of pain" level of 120 decibels, Motörhead cranked out 130 decibels on the Variety stage. As a result of the falling ceiling pieces that also brought forth structural safety concerns, the Variety maintenance man pulled the electrical switch and cut the power on Motörhead's performance. Putting Motörhead's event in perspective, the band's sound was so deafening that a neighborhood resident recorded the concert's audio from his living room. Of course, previous to this event, the late Lemmy Kilmister, frontman of Motörhead, often joked that his band was so loud that it would make a lawn die. While the band did not trigger lawn death on this December evening, as lawns were already winter-dormant, Motörhead, however, set the wheels in motion for Variety's demise. This performance was the beginning of the end for the lovely movie palace. Variety's neighborhood was not pleased with the continuing noise volume seeping from the venue walls, and Motörhead's performance was the proverbial straw that broke the camel's back. Consequently, a court ordered the shuttering of Variety's doors within two years of the Motörhead performance. Eventually, Motörhead released their 1999 live album *Everything Louder Than Everything Else*, and I always thought this album might be a fitting tribute to the 1984 performance that sealed Variety's fate.

The Variety Theatre, though, was not always a raucous Cleveland resident. Variety inaugurated as a grand Hollywood-style movie palace presence in 1927.

Architect Nicola Petti designed the 1,900-seat theatre. At the cost of $2 million ($29 million in today's dollars), the theatre featured a 350-seat balcony with 1,550 ground level seats and several box seat booths. An orchestra pit hidden beneath the extended stage and dressing rooms were at the service of stage shows. The theatre adornments were lavish and included glass-cut and colorful chandeliers, heavy textiles, brass hardware, marble, gold leaf detail, plaster ceilings, and walls showcasing dimensional decorative embellishments. Variety's ornate ceiling holds large oval recesses, once softly illuminated with concealed lighting. The theatre's 1927 opening on Thanksgiving Day introduced Clara Bow's movie *Hula*. The Variety Theatre is part of a block-long complex holding ten retail establishments originally featuring a bakery, grocery, and apparel stores. Thirteen one-bedroom apartments at 600 square feet command the second level.

Two years after Variety's opening, Warner Bros. purchased the theatre and showcased movies in the majestic theater palace style of this time. Many charity events featuring Hollywood royalty were part of Variety's schedule, too. Warner operated the theatre until 1954. The Community Circuit Theaters Company assumed control of Variety after Warner Bros. and managed the site until 1976, when Russell Koz purchased it. From the 1950s to the 1970s, the Sunday Matinees at Variety were big customer draws, but by the 1970s, Variety was becoming shop-worn with many unheeded repairs. Without a dedicated theatre parking lot, the parking situation created problems for the neighborhood too. With the theatre unable to secure first-run films, Variety evolved into a second-run theatre. Thus, as a second-run movie house, Variety turned into a profit losing enterprise, like many other palace-style movie houses across the nation. At this time, many large, single-screen urban theaters were flattened from coast to coast, but fortunately, Variety escaped this trend.

During the 1980s, Variety found a new entertainment niche with Koz steering theatre operations as a concert venue. Some rows of seating in the front of the theatre were removed to accommodate the concerts. Infamous bands took to Variety's stage, including INXS, Johnny Rivers Band, Black Flag, Metallica, Queensrÿche, Slayer, Dead Kennedys, Stevie Ray Vaughan, R.E.M., and, of course, Motörhead. Noise pollution, parking irritations, post-concert safety concerns, and loitering issues plagued Variety's neighborhood at this time. As noted, Motörhead's over-the-top performance was the catalyst for Variety's business cessation. The neighborhood nuisance issues made it to court, resulting in a court order to shutter the theatre in 1986. Variety grabbed a little more life for its footprint for a brief period when the site was used as a wrestling gymnasium, the Cleveland Wrestleplex. Finally, in the late 1980s, Variety sealed its doors, and the venue remained dark for decades. Still,

the Variety complex managed to earn a marker on the National Register of Historic Places allowing for a small shield of protection from the city demolition roster.

In 2002, a local politician joined with a local commercial administrator and scratched out a plan for Variety's redevelopment and restoration. From this interest, the Friends of the Historic Variety Theatre ("Friends") formed a non-profit group dedicated to the theatre's renovation. Friends stepped in to secure funding for the crumbling site and were successful in fomenting interest for a renewal of the site. In 2009, with the ultimate goal to restore Variety to its former beauty, Friends purchased the theatre through grants and other means of funding. Variety is slated to be repurposed as a large-screen theatre for screenings of classic films, children's films, and other theatre cinema. In 2016, and after thirty years of darkness, the Variety marquee illuminated along with the restoration of all of the elements of the original 1927 marquee. Each evening, Variety's marquee glow reminds its community that life still exists within this beautiful palace, and such a life is worth saving. In 2017, The National Trust for Historic Preservation awarded Variety with a "This Place Matters" award—an appreciation for historic structures. Cleveland also proposed installing a parking lot across from the theatre, which will alleviate many parking concerns during Variety events.

As I walked through a decayed Variety and photographed its beauty, hidden in too much darkness, I recognized Variety's craftsmanship and scale of detail as something that should never be discarded or demolished. Wandering through an old building such as this is an experience that lingers. There is so much cultural wonder and heritage tucked away in historical abandonments. Saving this grand palace is a gift to Cleveland—one that was slinking in the shadows for too long. After all, the house did not wholly come down in 1984 with Motörhead's shriek. Instead, Variety patiently waited for a second chance to bequeath the Cleveland community with art, history, and entertainment rooted in its grand style.

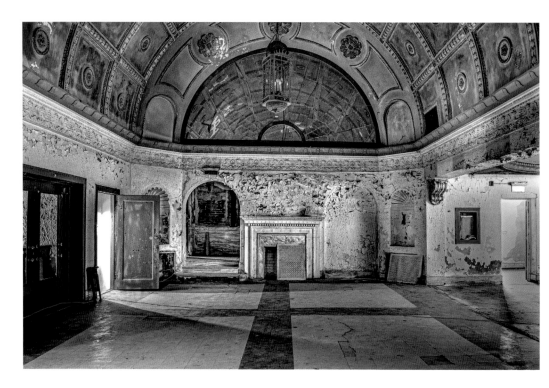

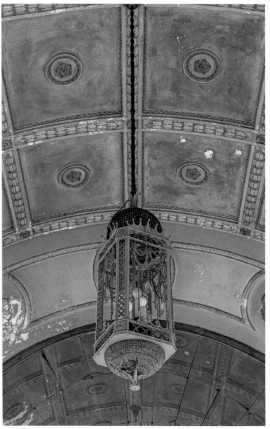

▲ **LOBBY:** The Variety Theatre, Cleveland, Ohio—a Spanish Gothic-styled venue, opened on Thanksgiving Day, November 24, 1927.

▼ **LOBBY CHANDELIER:** The Variety held hundreds of events, including stage presentations, films, concerts, and even wrestling matches.

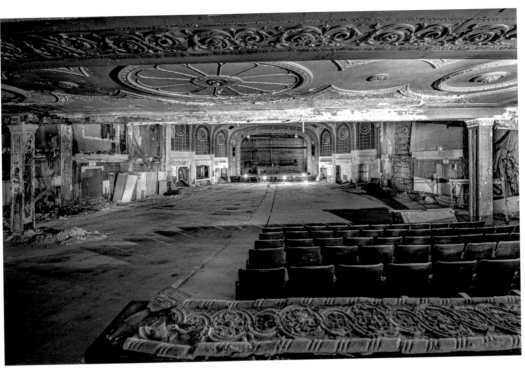

GROUND LEVEL: The ground floor held 1,550 seats, and the balcony added another 350 seats.

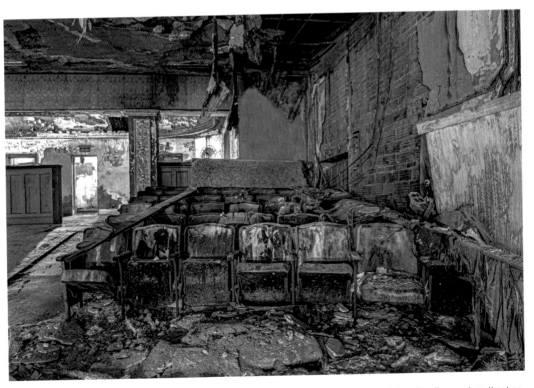

SEATING ON GROUND LEVEL: At one time, the Variety was considered one of Cleveland's premium theatres. The Variety complex also included retail establishments, and second level apartments.

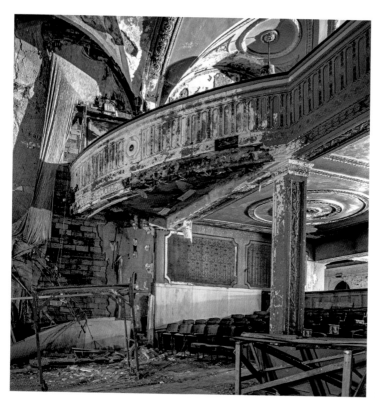

GROUND LEVEL AND VIEW OF BALCONY: The massive bowed ceiling was adorned with raised plaster embellishments.

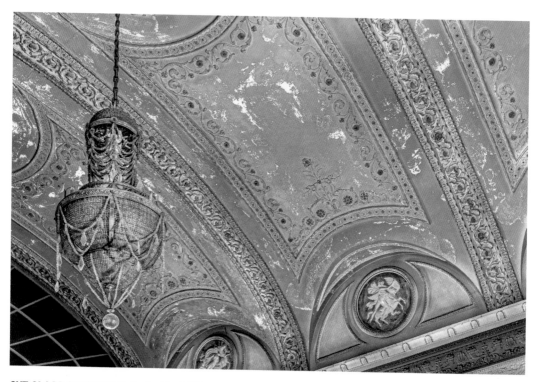

CUT GLASS CHANDELIER: During the 1950s and the early 1960s, the Variety's Sunday matinees were popular with the region's young baby-boomers.

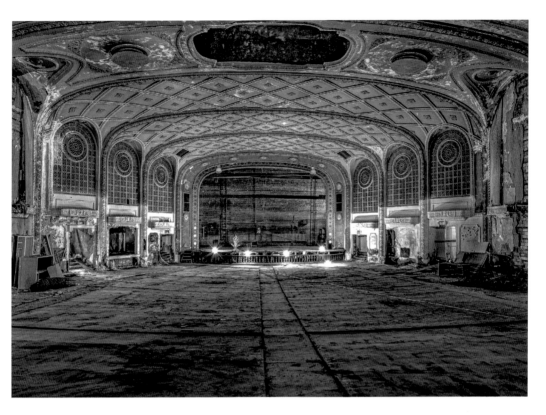

▲ **GROUND LEVEL:** In the mid-1950s, a vertical lighted sign, situated above the illuminated overhang entrance marquee, was damaged by a tornado, and this blade-styled sign was removed.

▼ **SEATING ON GROUND LEVEL:** The Variety balcony was closed during matinee time for fear of children falling over the railing, and to prevent food stains on the carpeting and upholstered seating.

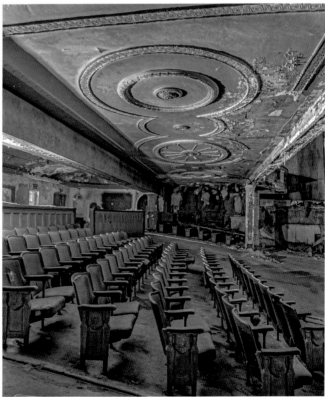

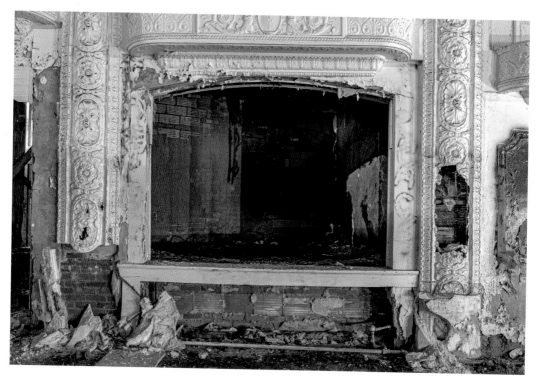

▲ GROUND LEVEL BOX SEATING: Not too many adults attended Sunday matinees. The 1950–60s matinee ticket prices were 12 cents for children under twelve years old, 13 to 17 cents for teenagers, and 75 cents for adults.

▼ PLASTER WALL DETAIL: Popcorn was available in the standard square cardboard containers at the cost of 12 cents. Oftentimes, the empty boxes were folded and thrown about in the theatre, like paper airplanes.

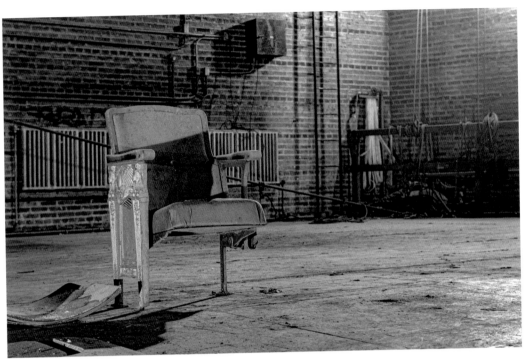

STAGE: The Variety often staged live events in addition to the movie presentations. In 1951, Clarabelle the Clown from the Howdy Doody Show appeared on the Variety stage.

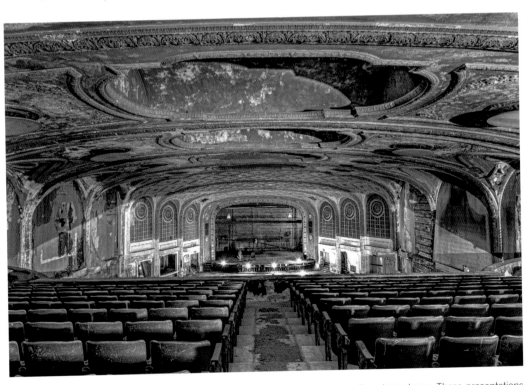

BALCONY: During the 1960s, the Variety hosted several horror and action stage shows. These presentations featured appearances by Frankenstein, Dracula, and mad scientists.

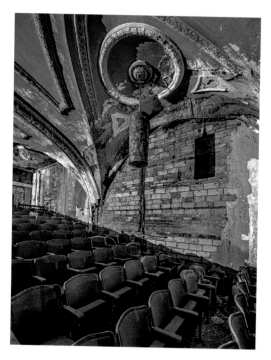 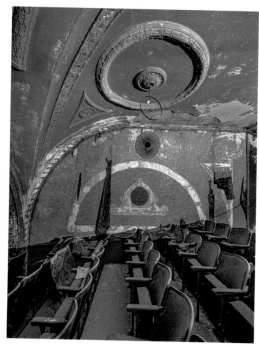

◄ **BALCONY SEATING AND CHANDELIER:** For a time, Variety was unable to secure first-run films and instead ran second-run films. James Bond films were a favorite with tickets at greatly reduced prices. Midnight movie showings were a favorite as well.

▶ **BALCONY SEATING:** The owner of the theatre in the 1970s and 1980s, Russell Koz, attempted to secure neighborhood lots for parking accommodations but was unable to obtain city approval. The parking deficit would be a problem for Koz with regard to ongoing theatre operations.

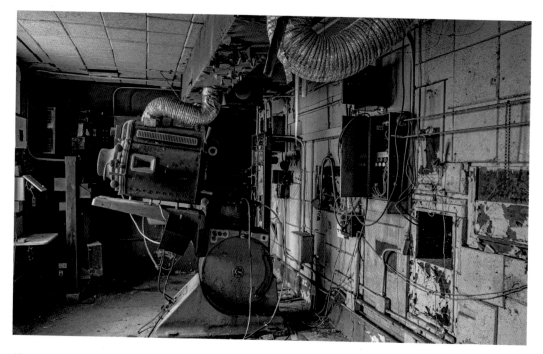

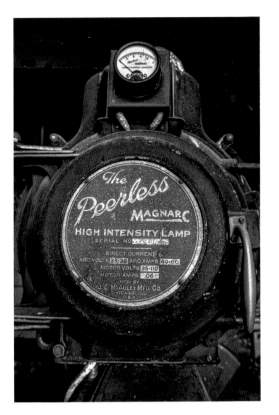 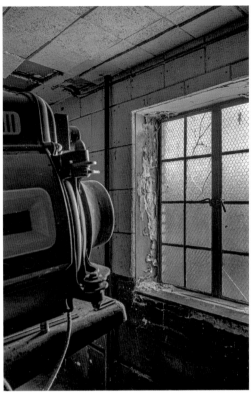

◄ **PROJECTOR:** Big name rock bands performed at the Variety and included Metallica, Slayer, Queensrÿche, Motörhead, Stevie Ray Vaughan, INXS, R.E.M., and Dead Kennedys.

► **PROJECTOR:** In 1984, Motörhead performed at the Variety at a sound level of 130 decibels. This performance broke the Who's world record for stage volume.

◄ **PROJECTION ROOM:** When second-run films became non-profitable for Variety, the theatre transformed into a concert venue, with rock band performances as a favorite.

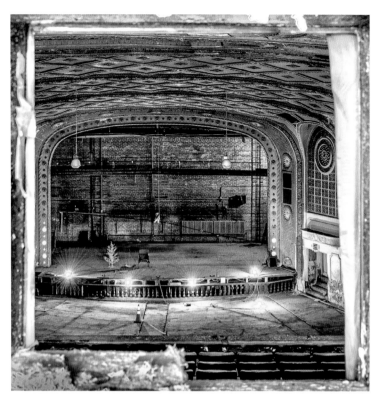

MOVIE PROJECTOR OPENING: Motörhead's volume caused Variety's ceiling to crack and shower the concert attendees with ceiling plaster.

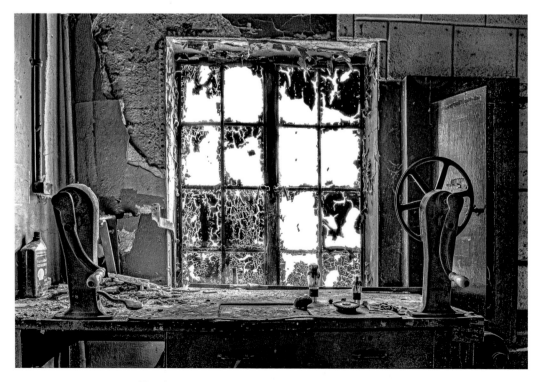

FILM PROCESSING AREA: Motörhead's performance was the straw that broke the proverbial camel's back regarding neighborhood noise nuisances, and thus, a court ordered the Variety to close two years later.

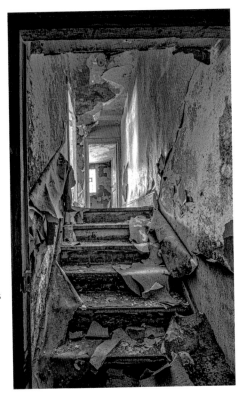

▲ **STAIRCASE TO DRESSING ROOMS:** Following Variety's shuttering, the neighborhood also experienced closings from other business merchants.

▼ **DRESSING ROOM:** In 1998, the Variety was sold and then sold again in 2002 to an owner with an interest in saving the theatre.

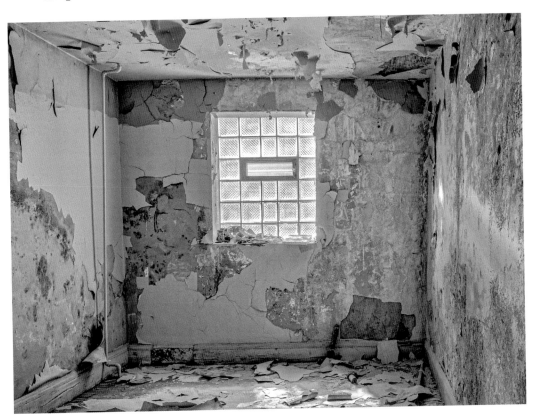

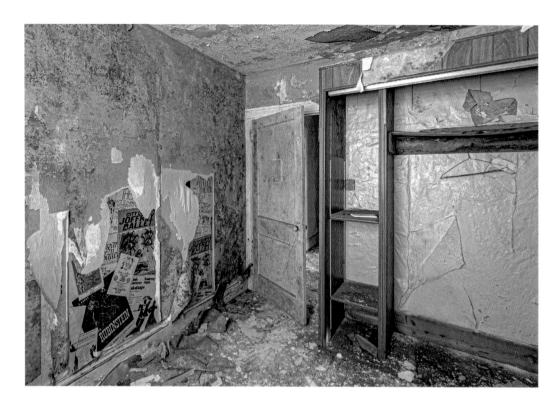

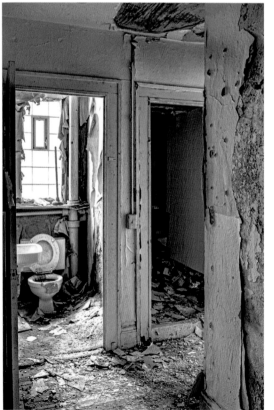

▲ **DRESSING ROOM WING:** The Friends of the Historic Variety Theatre, a non-profit organization, formed to restore the Variety Theatre to operational status.

▼ **DRESSING ROOM WING:** Ghost hunters believe the Variety Theatre is a top Cleveland haunted hot spot and claim nineteen spirits and specters are present within the theatre walls.

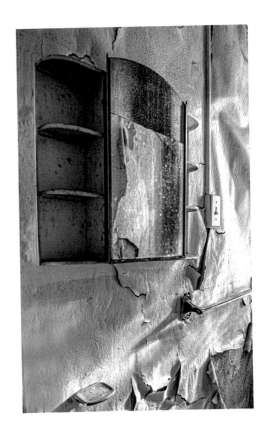

DRESSING ROOM: The first phase of Variety's rehabilitation included an upgrade to the electrical system. The second phase installed the marquee canopy and vertical blade sign—completed and illuminated in 2016.

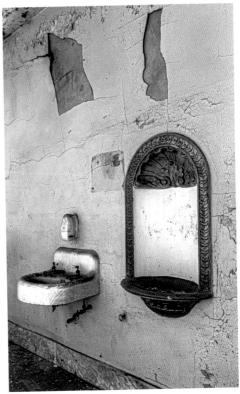

THEATRE LOUNGE: In 2017, the National Trust for Historic Preservation selected Variety as the winner of the "This Place Matters" awareness campaign.

3

THE HEARTS OF STEEL

I magine leaving your house for a typical Monday of work at Youngtown Sheet and Tube's Campbell Works, embracing the crisp fall air as you clutch your hard hat, thermos, and black metal lunch pail—your unfolding routine each day for decades. The only thing you probably ponder on this particular early fall morning is the outcome of the upcoming evening's Monday night football game featuring a showdown between your beloved Pittsburgh Steelers and San Francisco 49ers. You meet your co-workers before your work shift is about to commence, exchange chats about your weekends, and, of course, talk about the evening's football game, and get ready to seize the day for another week of work at the mill. On September 17, 1977, though, no Youngstown Sheet and Tube steelworker would likely be prepared for what hit them shortly before 8 a.m., nor did they realize their lives would be altered forever in a New York minute. On this September morning, 5,000 Youngstown Sheet and Tube employees were abruptly pink-slipped. The steel giant drew the curtain on its operations without warning. This devastating event is known as Black Monday. Many business analysts consider Black Monday as the beginning of the end for Ohio's regional steel industry. Many more regional heavy industry mills, including some U.S. Steel divisions, and Republic Steel Corporation joined the Youngstown Sheet and Tube Campbell Works' closing parade shortly after that. Industries and services in support of the steel sector were swept into the shuttering tidal wave as well.

Before Black Monday, Youngstown, Ohio, and its surrounding area was a thriving industrial zone. Youngstown steel facilities produced so much fortune that the region was indeed a standard of the American dream. Family median incomes and homeownership in this area were among the highest in the United States. Like

many cities cradled in America's steel-producing belt, the economy flourished until American manufacturing faced declines in the 1970s. The once-booming towns saw their means of income and stability crack on multi-levels in the wake of "out of business" manufacturing facilities.

During its economic heyday, Youngstown Sheet and Tube built the Iron Soup housing complex for its workers and families. As I surveyed the Youngstown Sheet and Tube Campbell Works company village, Iron Soup, a portrait of Black Monday's resulting lifestyle surrender emerged—desolation is front and center. The impact of lost hope is immediately evident with an initial scan of the site. Within five years of Black Monday, 50,000 regional manufacturing jobs vanished, as well as 50,000 American dreams. Even amid the ruins, however, one can still grasp the charming design that once promoted community, security, and camaraderie for the mill workers and their families—the hearts of steel.

Company villages, or towns, were creations of the industrial United States. Mines, mills, and factories often arose in areas absent a population in support of the industrial works. To provide a workforce for company operations, companies needed to build a community that housed employees and provided services and amenities. During the industrial revolution, housing settlements fabricated by businesses sprouted across the nation. Some company communities were quite lovely, and some were quite awful. If the company town concept is not too familiar to many Americans, it is because few company towns exist today. Campbell's Iron soup village was once an attractive and vibrant community in the not so distant past.

Youngstown Sheet and Tube has a solid history of manufacturing, dating to 1888. Initially named Mahoning Valley Iron Company, the company evolved into Youngstown Iron and Sheet Tube Company five years later. Youngstown Sheet Tube emerged on the industrial scene with an outlay of $600,000. While initially manufacturing sheet and tube materials, the company later expanded to become one of the nation's most essential steel producers and diverse product providers. The company grew steadily but faced labor tensions with worker strikes and violence, especially in 1916. For twelve hours on January 7, 1916, strikers burned and looted nearly 100 city blocks of East Youngstown businesses and residences. Ohio's governor, Frank Willis, summoned the National Guard to suppress the labor uprising, but when Youngstown Sheet and Tube offered wage increases, the revolt quelled.

After the strike, Youngstown Sheet and Tube executives examined the ancillary problems of substandard employee living conditions and proposed plans for a company town in Campbell, now known as Iron Soup. In 1918, Youngstown Sheet and Tube commenced with the construction of worker home communities. In addition to the Iron Soup community, Youngstown Sheet and Tube built three other housing

complexes—two in nearby Struthers and one in Youngstown. All communities centered on workforce divisions, with the Iron Soup community accommodating foreign-born and African American workers. All housing communities incorporated a neighborhood-friendly character with an emphasis on strengthening the family unit. The Iron Soup homes built between 1918 and 1920 were the first pre-fab concrete structures in the world. A public square was a focal point of the village, and a nearby community house, gymnasium, several playgrounds, and school completed the site plan. With a pre-cast concrete structure for Iron Soup housing, the homes were solid and strong. The walls between each unit were 8 inches thick. Each housing unit had electricity, indoor plumbing, a laundry, and a shower in the basement to allow workers to wash before entering their living space. Small gardens were located in the rear of the housing units.

Youngstown Sheet and Tube prospered once the company towns were completed and reinforced the stabilizing bond between employer and employee. By the mid-1950s, with over $600 million in annual revenue, Youngstown Iron and Sheet Tube was larger than Coca-Cola, Heinz, Johnson & Johnson, Anheuser-Busch, and Marathon Oil. With 30,000 employees and healthy revenues, Youngstown Sheet and Tube ranked at 70 on the Fortune 500 list. Unfortunately, the robustness of the steel sector was not to last and began to unravel in the 1970s.

When the mill closed on Black Monday, Campbell and the Iron Soup residents suffered and never recovered. With so many unemployed after the collapse of Youngstown Sheet and Tube, along with the closing of so many additional mills and services in support of the steel industry, the absence of work opportunities in the area forced many to abandon their cherished company homes. Iron Soup still stands but is mostly vacant and decaying. A few families still claim Iron Soup as their home, with residents scattered among the forsaken, boarded, and deteriorating concrete structures. The manifest bleakness, nonetheless, is a constant reminder of broken dreams.

The Ohio Historical Society sought state historical site status for Iron Soup, and in 1982, the company town earned its marker on the National Historic Site roll. Throughout the decades, though, many vacant Iron Soup homes suffered van-dalism, arson, and scrapping. In 2011, the Iron Soup homes secured a spot on the Endangered List. Currently, the Iron Soup Historical Preservation Company owns more than twenty of the remaining 179 unoccupied dwellings. The Historical Preservation group wants to secure and renovate the vacant housing and reserve these units for American veterans and low-income Campbell citizens.

Forty years ago, Youngstown Sheet and Tube workers walked into their factory for the morning shift, and within an hour of their arrival, faced individual and family

turmoil. The devastation to the community never ceased. Today, 22 miles of steel mills that once lined the Mahoning River are demolished or rusting. The ripple effect of so many closings took hold, too, as support services such as restaurants, retail establishments, service providers, grocery purveyors, and more caved to the new reality of lost business.

I grew up in a Pennsylvania steel region with the backdrop of the 24/7 roar of steel mills, the lingering coke scent from the mill ovens, and a ginger luminosity shading the evening sky, courtesy of the open-hearth steel blast furnaces. The silence and evening darkness surrounding these former titans of industry seems abnormal compared to the past environmental attributes that were once ever-present. Even though no company towns supported the steel mills in my city, the mills' adjacent neighborhoods were similar to company towns. At the very heart of these neighborhoods were generations of families living within blocks of each other. These neighborhoods were tight-knit and spirited communities. These folks were proud of their contributions to a strong America—especially the Arsenal of Democracy. These qualities are no different for the people that lived in Iron Soup and served Youngstown Sheet and Tube. Youngstown Sheet and Tube and its Iron Soup community is a familiar American story, whether rooted in Ohio or Pennsylvania—when employment vanishes, cultural unity shatters. The workers of the once-mighty steel manufacturing giants claim the true hearts of steel. With the steel manufacturing sector's demise, lives and community bonds dismantled and substituted the unwanted reality of rust, lost dreams, and broken hearts of steel.

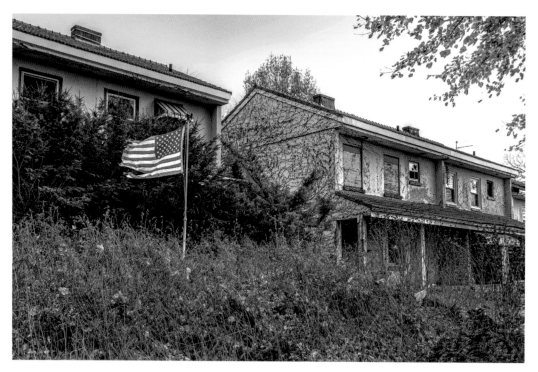

IRON SOUP VILLAGE: Iron Soup is a collective of Youngstown Sheet and Tube company homes that once served the industrial community.

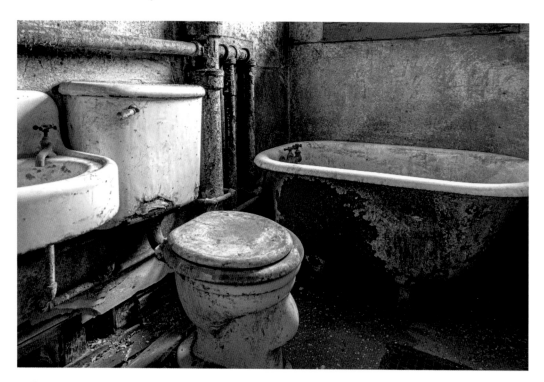

BATHROOM WITH CLAW FOOT TUB: When the means of industrial production withered away in the 1970s, Iron Soup residents lost their stable means of income.

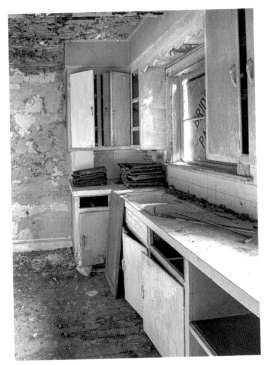

◄ **KITCHEN:** Regional industrial collapse resulted in economic instability and forced many to abandon homes.

► **CEILING FIXTURE:** September 19, 1977, marked the beginning of the end, known as Black Monday, when 5,000 Youngstown Sheet and Tube Campbell Works workers received job termination notices.

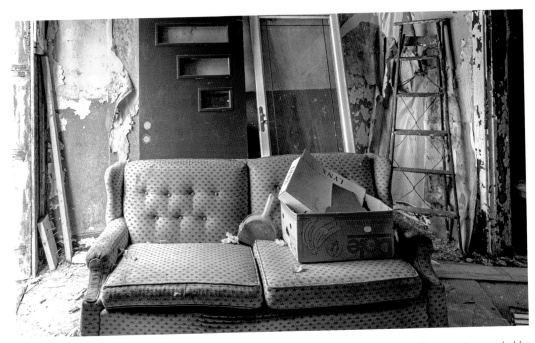

REMNANTS OF A LIFE: The three Youngstown Sheet and Tube company home villages were separated by demvographics. Campbell's Iron Soup was a community of foreign-born and African American employees.

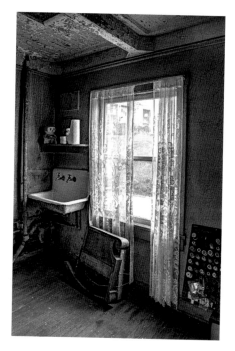
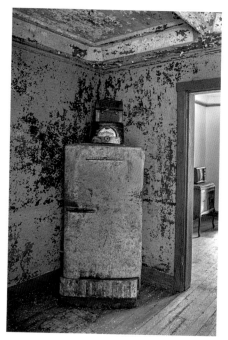

◄ **PRESERVED KITCHEN:** In 1916, a violent labor strike erupted in Campbell, with the destruction of many residences and businesses. After this, the Youngstown Sheet and Tube executives evaluated the issue of labor discontent.

► **REFRIGERATOR:** After the 1916 riot, Youngstown Sheet and Tube executives made efforts to appease labor discontent and constructed company housing for its employees.

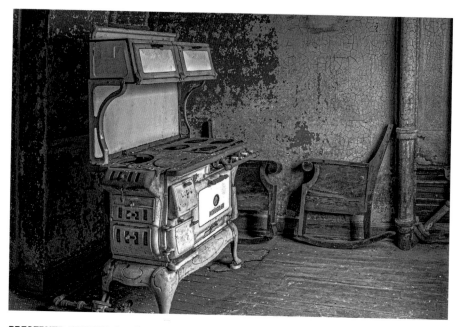

PRESERVED KITCHEN: Iron Soup's home units were the first pre-fab concrete construction housing units in the world, and still stand solidly as a testament to their structural stability.

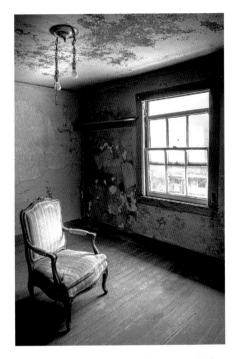 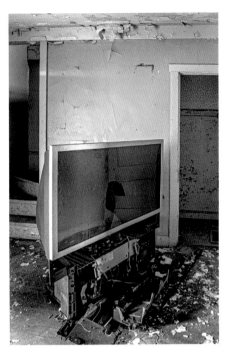

◄ **REMAINS:** While the home unit concrete shells are still structurally stable, most homes are abandoned for decades, and neglect has taken its toll.

▶ **REMAINS:** Iron Soup contained the first modern apartment complex in the world—designed for communal living.

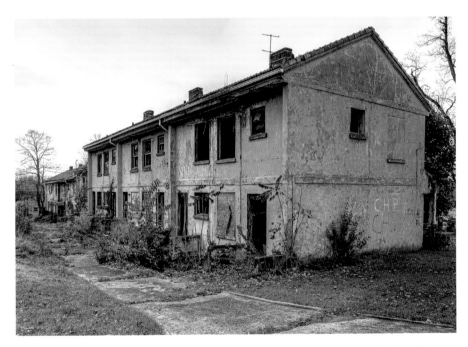

HOME UNIT SECTION: For several years, the Iron Soup community has been listed on the Most Endangered Historic Sites in Ohio.

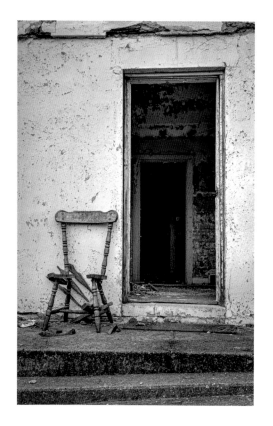

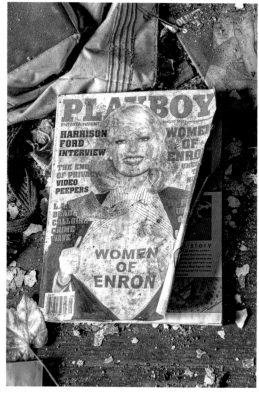

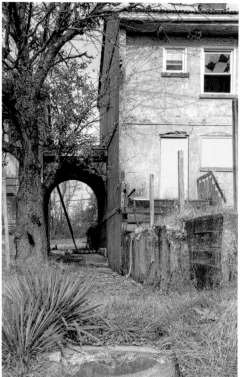

▲ **ENTRANCE TO HOME:** Renovation and reconstruction plans for Iron Soup continue to be stymied by tax debts, unpaid utility bills, and a lack of manpower.

▲ **REMAINS:** Volunteers do most of the renovations performed in the Iron Soup community.

▼ **LANDSCAPE OF COMMUNITY:** When the Iron Soup community debuted, the units had hot and cold running water, electricity, push-button and pull chord lighting—amenities of modern-day living in 1918.

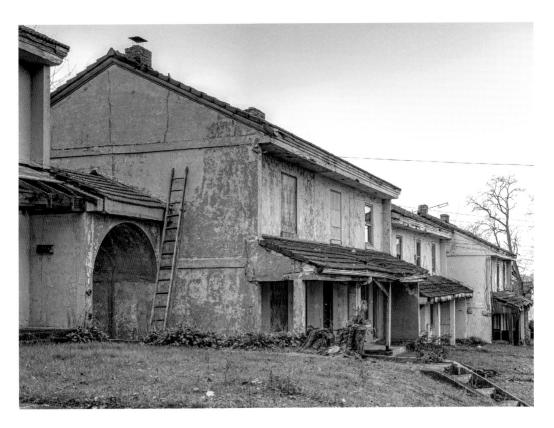

▲ **LANDSCAPE OF COMMUNITY:** Iron Soup residents constructed the first 360-degree crane.

▼ **LANDSCAPE OF COMMUNITY:** At one time, the Youngstown Sheet and Tube Company was the fifth largest employer in Mahoning County and the number one employer in Campbell.

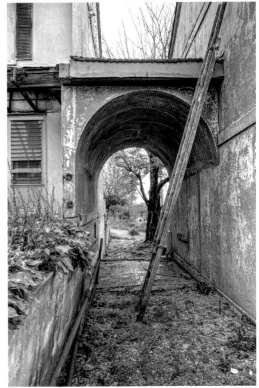

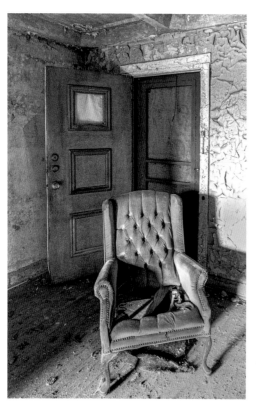

▲ **REMAINS:** At its production peak, nearly two-thirds of all steel produced in the world came from the United States, and Youngstown Sheet and Tube Company was the third-largest steel producer.

▼ **REMAINS:** More than 178 Iron Soup units were constructed for the Youngstown Sheet and Tube workers.

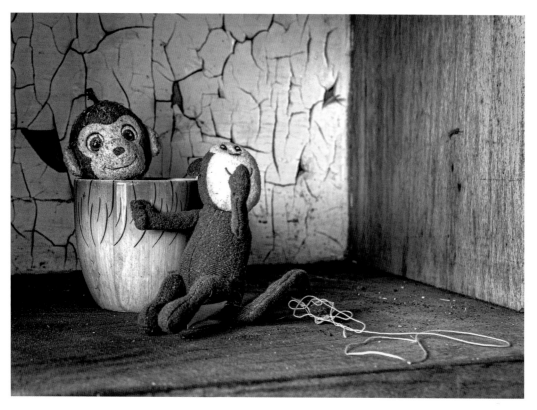

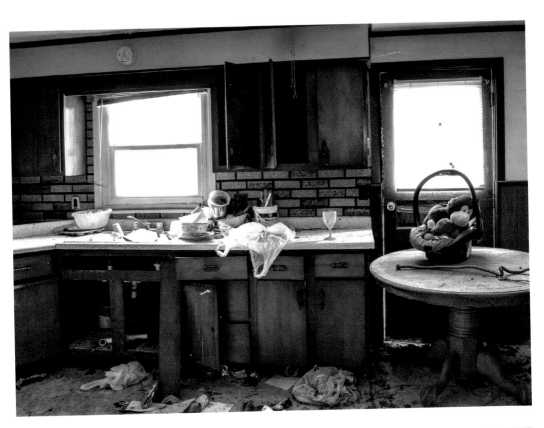

▲ **KITCHEN:** The action of 5,000 Campbell Works employees losing their jobs on Black Monday precipitated other industrial closings with ultimately, 50,000 regional employees losing employment.

▼ **REMAINS:** In 1982, the Iron Soup homes were declared a National Historic Site because of their unique concrete construction.

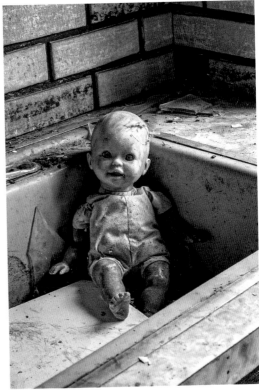

REMAINS: Demolition of the Iron Soup concrete units is too costly, and it also overlooks the community's economic potential with the renovation of these homes.

WINDOW VIEW: An attempt to demolish a Pennsylvania concrete home village failed after the use of more than 100 sticks of dynamite, and a $200,000 expenditure. The end result of this destruction attempt was minimal damage on just one of the forty concrete homes, thus, demolition of Iron Soup is an unlikely possibility.

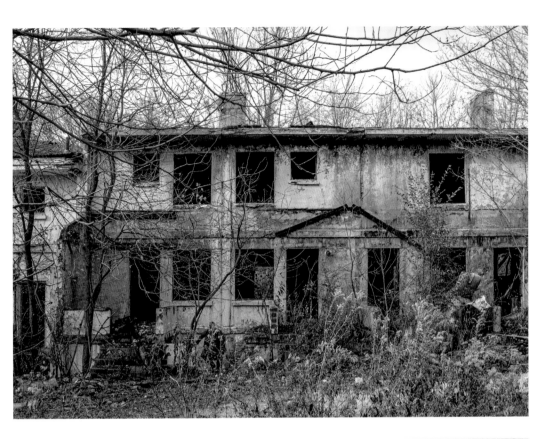

▲ A HOME UNIT SUBJECTED TO ARSON:
The non-profit group, the Iron Soup Historical
Preservation Society, is focusing its efforts on
restoration of one housing unit at a time, as well
as rentals of some of the renovated units.

▼ REMAINS: When Iron Soup was first
constructed, Youngstown Sheet and Tube
provided its foreign-born workforce with
opportunities to attend classes about American
family ideals and living standards.

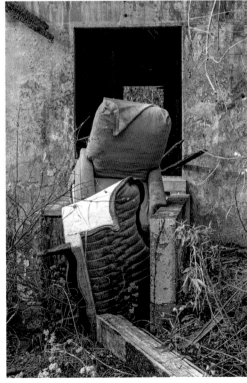

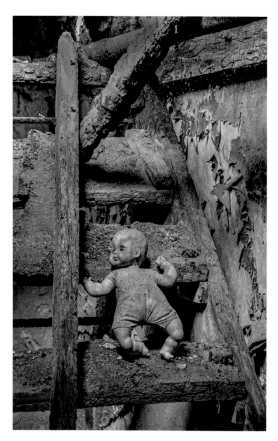

▲ **REMAINS:** A child's doll remains in the ruins of an Iron Soup home that was subjected to arson.

▼ **A CURRENT IRON SOUP RESIDENT'S MODEL A IN THE WEEDS:** Between 1902 and 1926, Campbell was called East Youngstown. After 1926, the city was renamed for local industrialist James Campbell, and at this time, the chairman of the Youngstown Sheet and Tube Company.

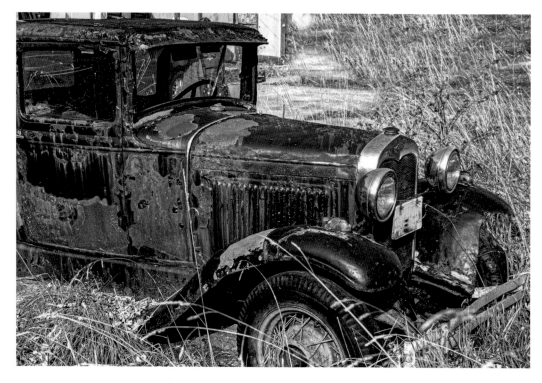

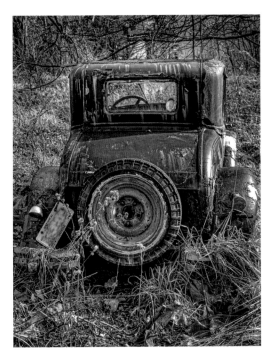

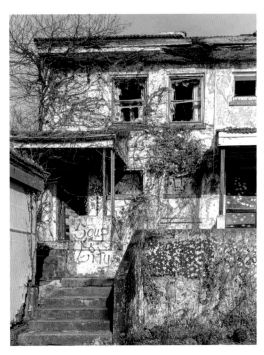

◄ **A CURRENT IRON SOUP RESIDENT'S MODEL A IN THE WEEDS:** Campbell's largest population occurred in 1930 and neared 15,000. Today, Campbell's community approaches 8,000.

▶ **DERELICT IRON SOUP HOME:** A few families still call Iron Soup home. Their residences are scattered amid the ruins.

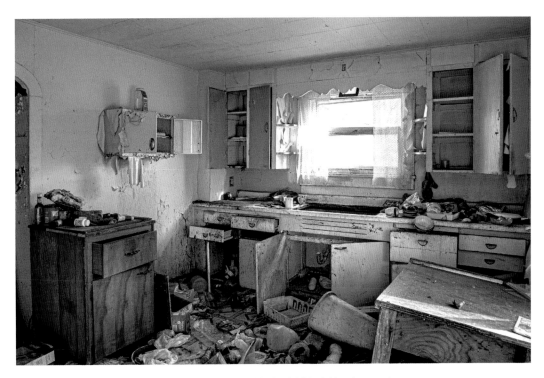

KITCHEN: Iron Soup never recovered after 1977s fateful Black Monday event.

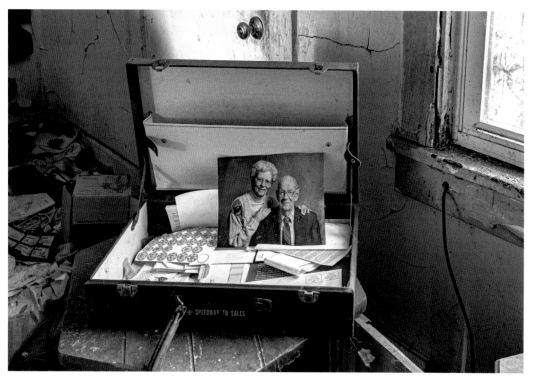

DISCARDED MEMORIES: What causes families to abandon such valued keepsakes?

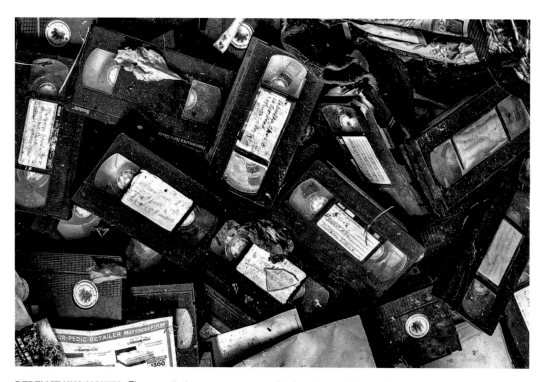

DERELICT VHS MOVIES: The cassette tapes were once a collection of entertainment for a family, but now they are merely a heap of cast-off artifacts.

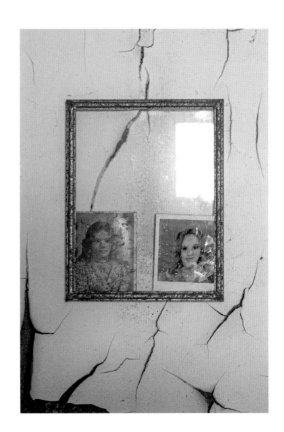

DISCARDED FAMILY PHOTOS: Is the pain of leaving a family home so scarring that family photos are left behind?

REMAINS: The long-term Iron Soup development plans include the preservation of the historical character of the company homes.

FORGOTTEN: An Iron Soup development plan includes plans for the world's first sustainable apartments.

REMAINS: Other long-term Iron Soup development plans include restaurants and cafes, specialty shops, a museum, ghost tours, and an outdoor theater.

4

THE LITTLE GIANT

When it commenced operations in 1957, the Pittsburgh and Lake Erie Railroad ("P&LE") Gateway Yard was a needed innovation for the smooth operations and success of the P&LE. With a 200-acre footprint, the railyard operated between Youngstown and Pittsburgh. The P&LE mostly served the regional steel mills and other heavy industries. Even though P&LE's route was somewhat short, mileage-wise, it moved more massive hauls than the rail norm. Accordingly, the P&LE was coined, "the Little Giant" because it functioned on only one-tenth of 1 percent of United States railroad miles, yet pulled 1 percent of tonnage courtesy of the steel mills' weighty use of raw materials. The P&LE joined with the steel mills, and *vice versa*, and created a symbiotic relationship that advanced operational success for the rail line and the steel mills.

William McCreery created P&LE on May 11, 1875. McCreery was a well-known businessman, merchant, and naturally, a railroad builder. McCreery set the first rails in Beaver Falls, Pennsylvania in 1877 with the final tracks linking Pittsburgh in 1879. Even though this line was a single-track line, the P&LE nevertheless realized instantaneous profits, and such proceeds allowed for more improvements and additional rail lines. By 1970, P&LE controlled 211 miles of road on 784 miles of rail. Most of P&LE's income arose from the movement of coal, coke, iron ore, limestone, and steel.

P&LE's Youngstown Gateway Yard functioned as a site for the classification and sorting of freight cars and offered an interchange with the Baltimore and Ohio Railroad and the New York Central Railroad. Most of the train cars at this site served the many Youngstown steel mills. Initially, the Gateway Yard held several structures, with many buildings no longer standing. The Gateway Yard included a classification area of the yard, control tower/office building, diesel locomotive servicing structure,

and a rail car repair facility. The yard tower resembles an airport tower but held the main office as well. A man-made earthen hump in front of the tower served as the elevated ramp that sorted the freight cars.

The Gateway Yard and the P&LE ceased operations in 1993. At this time, the CSX rail line absorbed the P&LE. The shuttering of so many area steel mills into the early 1990s accelerated the P&LE and Gateway Yard closure. Many tracks around the Gateway Yard have been removed, with some facilities remaining on the Gateway footprint, albeit in crumbling condition.

During the American deindustrialization period of the 1970–90s, the rail industry was not immune from this trend's negative effects and continues to struggle and face monumental challenges for its survival. The rail industry once employed more than one million, but now holds a workforce of less than 200,000. More than half of the gateway and hump yards in North America closed within the past two to three decades. The rail industry decline results from many factors, including mergers and consolidations, a shift in traffic from boxcars to containers, and new technologies driving business away from rail transportation. The manufacturing slump, however, is the biggest reason for the weakening of the rail industry and continues to impact today's rail industry. Shipments are down for automobiles, coal, grain, chemicals, and consumer goods, with crude oil as the only positive shipment marker.

The rail service downturn also reflects the damage from the U.S.–China trade war, as this makes shippers more circumspect and cautious concerning the logistics associated with their freight loads and exports-imports balance. Unfortunately, a positive rail growth curve does not appear on the economic horizon. The railroad, nevertheless, is a tangible sign of the ongoing trauma within the industrial sector. The profound industrial operational transformations in the economy join with so many middle-class jobs on or near the chopping block. Within the past few years, rail volume sloped southward so much that some economists identify the current times as a freight recession. Freight troubles are historical predictors of financial crises within the more general economy framework because such concerns are proper gauges of how much merchandise and material is heading to the market. Since World War II, every economic plunge has arrived on the heels of plummeting freight traffic. If economists claim the United States is stymied within a freight recession, this does not bode well for the broader economic outlook.

It seems the Ohio Gateway Yard's interdependence on steel and heavy manufacturing was the primary factor contributing to its demise. The Little Giant is no longer a functioning entity with just a hint of its former greatness peeking through the tall brush, weeds, and stacks of derelict rail ties at the deserted Gateway Yard. Like so much of the life in the Mahoning Valley area Eastern Ohio, every segment, not just the rail line, aches due to the collapse of the steel industry.

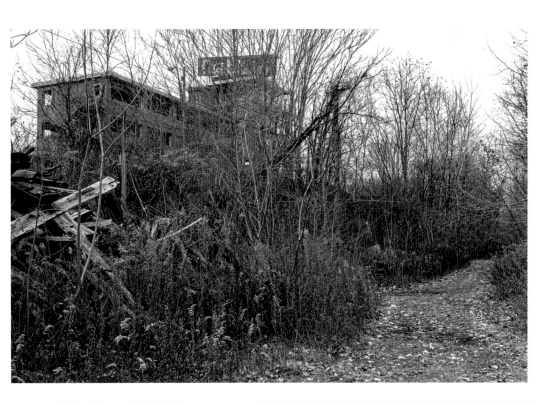

▲ **GATEWAY YARD TOWER AND ADMINISTRATIVE BUILDING:** The Railroad Gateway Yard for the Pittsburgh & Lake Erie Railroad ("P&LE") opened in 1957.

▼ **TUNNEL TO GATEWAY YARD:** An access tunnel appears under the Gateway Yard's man-made elevated hump.

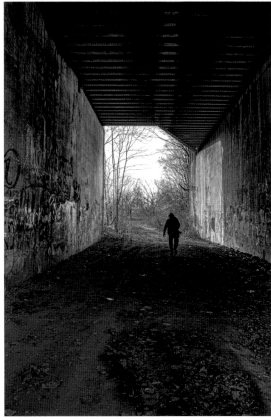

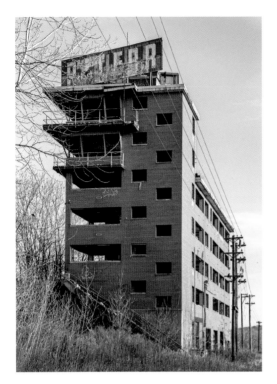

◄ **GATEWAY TOWER:** The Gateway Yard was 5 miles long. The P&LE was coined the Little Giant because it moved more tonnage than the average haul for a short railroad.

► **STAIRCASE NEXT TO GATEWAY TOWER:** The P&LE Gateway Yard sits abandoned since the CSX absorbed the P&LE in 1993.

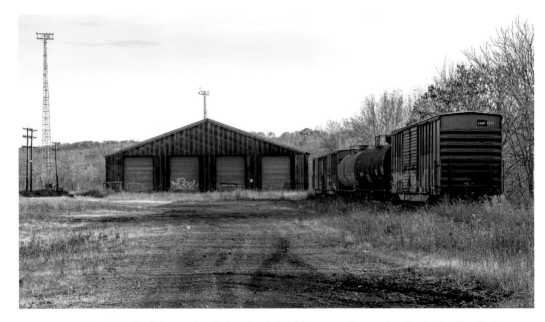

RAIL REPAIR FACILITY: The Gateway classified and sorted freight cars and was a junction for the New York Central Railroad and the Baltimore and Ohio Railroad.

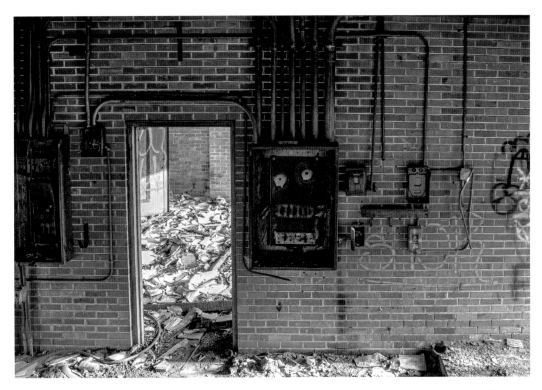

GATEWAY TOWER: The tower's design resembles an aircraft communications tower. The tower housed the main Gateway office, too. A man-made elevated hump appears in front of the tower, which was designed for freight car sorting.

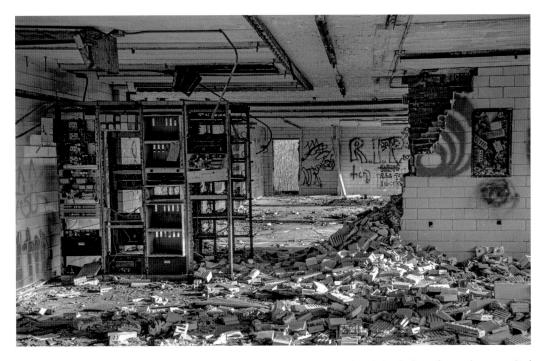

GATEWAY SERVER: Once CSX absorbed P&LE, the Gateway Yard closed shortly thereafter, and as a result of the many steel mill closures from the 1970s to the 1990s.

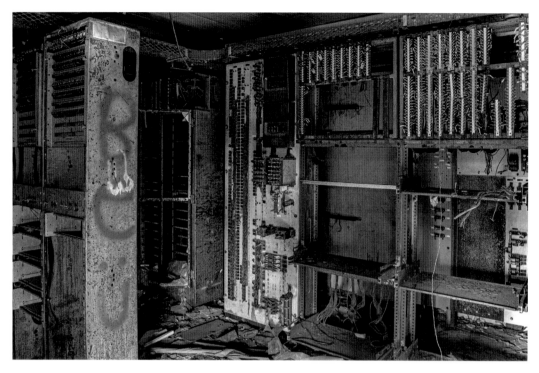

GATEWAY SERVER ROOM: Within the past twenty-five years, more than 50 percent of North American rail hump yards closed.

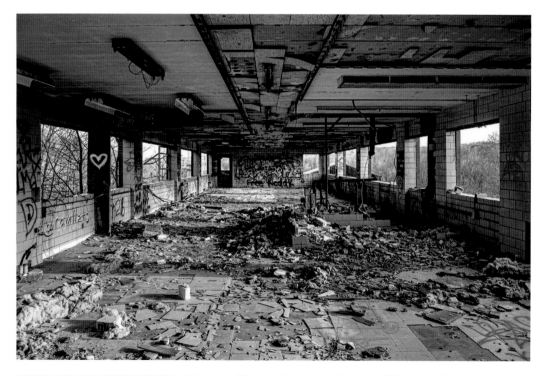

OFFICE AREA OF GATEWAY TOWER: A hump yard is a constructed elevated area within a rail yard where the force of gravity moves sorted rail cars along a network of tracks.

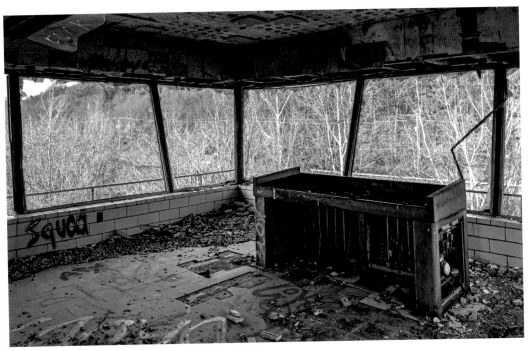

CONTROL ROOM FACING GATEWAY HUMP SORTING AREA: Today, many hump yards are considered inefficient and are instead converted to flat switch yards, where employees perform ground level operations for the sorting of rail traffic.

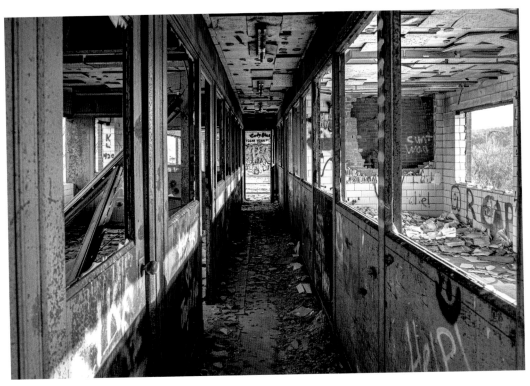

GATEWAY OFFICES: The Gateway yard was built on more than 200 acres.

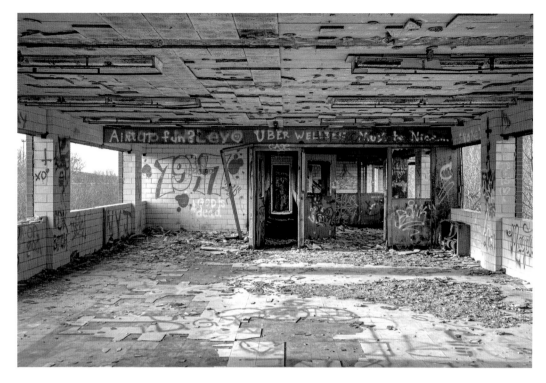

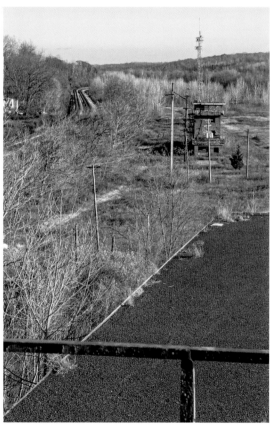

▲ **GATEWAY OFFICES:** The office/tower facility shows extensive vandalism with every window broken in the structure, along with much graffiti on walls and surfaces.

▼ **REMOTE ADMINISTRATIVE BUILDING IN GATEWAY YARD—VIEWED FROM TOWER:** The tower is visible from a busy highway, and the CSX main rail-line (visible in photo) runs between the tower and the road.

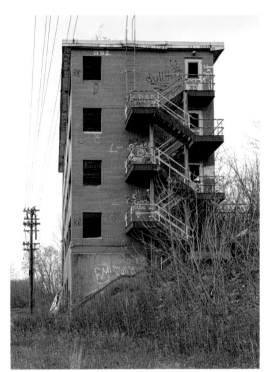

▲ **SECOND ADMINISTRATIVE BUILDING:** At one time, an elevated footbridge extended over the highway to the Gateway Yard. The footbridge also spanned the P&LE rail line.

▼ **TUNNEL EXIT FROM GATEWAY YARD:** A smaller tunnel appears beneath the lower part of the elevated hump that ascends to the Gateway tower.

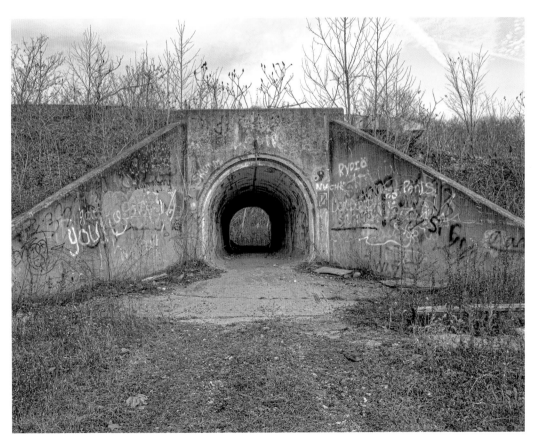

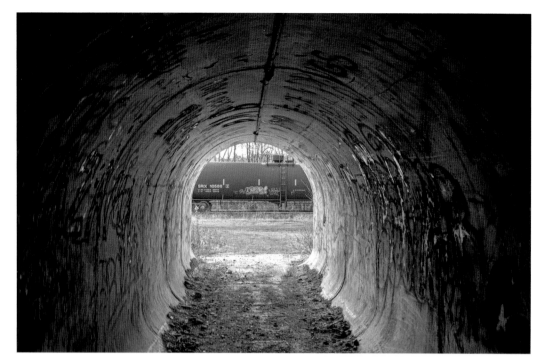

TUNNEL ENTRANCE TO GATEWAY YARD: A footbridge, no longer standing, allowed access to the Gateway Yard, and this tunnel beneath the Yard's elevated hump provided access to the Yard.

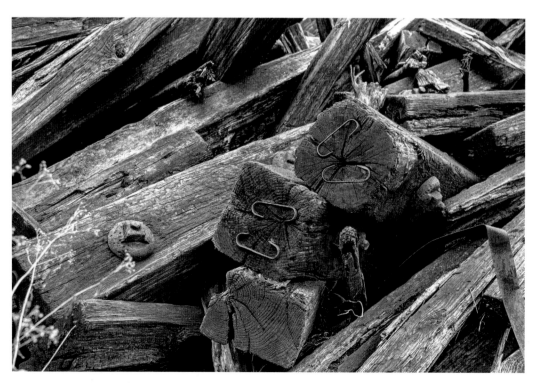

HEAP OF DISCARDED RAILROAD TIES: What once served as the base for freight cars to transport coal, coke, iron ore, limestone, and steel now holds cast-off rail ties piled in a heap next to the Gateway tower.

5

SACRED LOSS

While many grieve for the loss of their homes, such as the former residents of Campbell's Iron Soup community, there is also anguish and lament with the disappearance of so many sacred places within a neighborhood and city. A church, synagogue, mosque, or any religious structure does not merely exist for its worshipers; it also fosters the common good. A sacred place is a local, identifiable, and accessible sanctuary for citizens in need of refuge from life's storms. A sacred place is a shelter where one can seek a higher spirit when feeling lost and find community with the onset of loneliness. Additionally, these sacred places offer services beyond spiritual nourishment. These sites often also serve as voter polling places, AA meeting sites, child care centers, senior program facilitators, food banks, tutoring locations, and so much more.

Sacred places are an example of what urban sociologist Ray Oldenburg refers to as a "third place." Third places are dedicated to community and fall between the first place (home) and second place (work). In addition to sacred spaces, third places can also be coffee shops, hair salons, post offices, main streets, bars, bookstores, parks, and fellowship centers. Third places are community builders, and especially in the case of sacred sites, provide spots where people share their worries, happiness, and find renewal. Third places serve a vital and inimitable social and civic purpose. Sacred places are, in essence, civic institutions, albeit not directly linked to government or governance codes. Sacred places serving as civic institutions are settings where people can feel safe and discuss their concerns with the broader community.

Sociologists and political scientists have long warned of declining civic institutions' effects and the resultant threat to a healthy democracy. Indeed, Alexis de

Tocqueville, the great scholar of American democracy, believed that religion was essential for preserving freedom in a democratic society as a political institution and civic association. While the internet and social media are usually identified as connectors of people, the reality is that social media seems to deepen divisions in society and fuel separation. With the rise of social media, many comfortable third places vanished, especially those identified as sacred third places. Even though third place decline is also due to a population exodus to the suburbs since World War II, social media, nevertheless, appears to accelerate civic space flight and serve as its substitute forum.

Despite the perceived effect of social media on sacred place disintegration, Americans frequent church less and less. Thus, churches are forced to adapt to a new unwanted reality. The church is a third place at risk. The function of religion in American society is changing in that the percentage of Americans who identify as religious has been in constant decline. Those not holding a religious affiliation comprise about a quarter of the American population. The decline in religiosity has meant, of course, that fewer Americans go to church. Americans' waning church attendance means that one of the oldest third places in America does not hold the value it once did. Accordingly, sometimes church abandonment is the only option for such an institution. Lack of interest, lack of funds, parish consolidations, and as in steel communities, population flight, contributes toward church closings.

I visited an abandoned eastern Ohio church that also held a school. This complex was seated on a raised plot in a lovely community and surrounded by brick single-family homes. This church complex seemed to fit into the civic warmth mold of a third place. The interior of the church, though, displayed terrible decay, with warped, soft floors, collapsed sections, and heavy black mold. The interior flooring seemed on the verge of collapse, and unfortunately, beyond reasonable salvage. A neighborhood resident indicated that the church was on the local government roster for a visit from the wrecking ball in short order. At one time, this church seemed to be a one-stop-shop for the community's needs as it offered spiritual worship, schooling for the neighborhood children, and even appeared to offer craft classes. For 100 years, this community came to this church center for life events—educational milestones, baptisms, confirmations, marriages, and funerals. I suspect the closing of this church was mainly due to the collapse of the area steel industry. People left, and the church could no longer maintain its workings with such a diminished population. I imagine the old friends and congregants who once gathered here never imagined they would also mark their own church's death. Will Facebook be a proper soul-enriching substitute for this former third place?

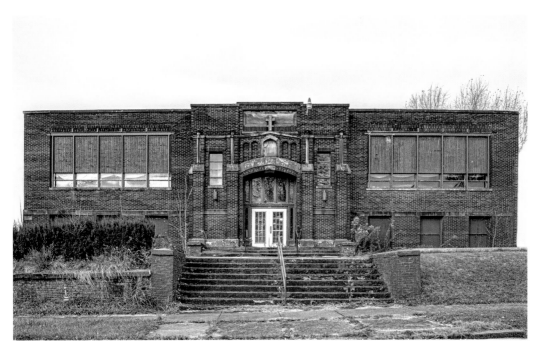

CHURCH/SCHOOL ENTRANCE: Sharp drops in church turnout, aging parishioners, population flight, and cultural swings away from organized religion have left many communities reeling with the loss of their places of worship and social connection.

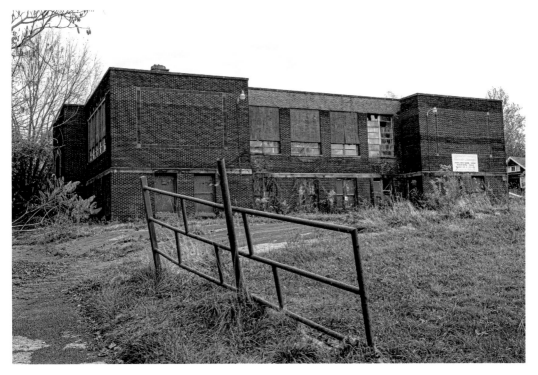

REAR OF CHURCH/SCHOOL: Sundays were once family days and included attendance at church and after-church activities.

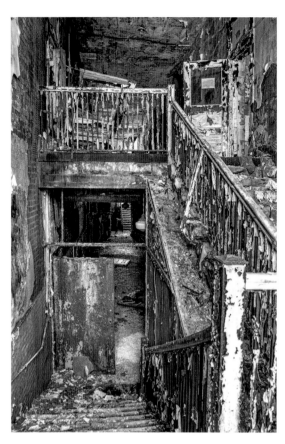

▲ **VIEW TOWARD SECOND FLOOR AND BASEMENT:** The rising number of church closures is not limited to a section of a state. Rural, urban, and suburban communities across the nation are facing this reality, too.

▼ **CLASSROOM:** Church closings and mergers leave social voids in communities where churches frequently hosted child care, senior programs, food banks, tutoring services, and many other community offerings.

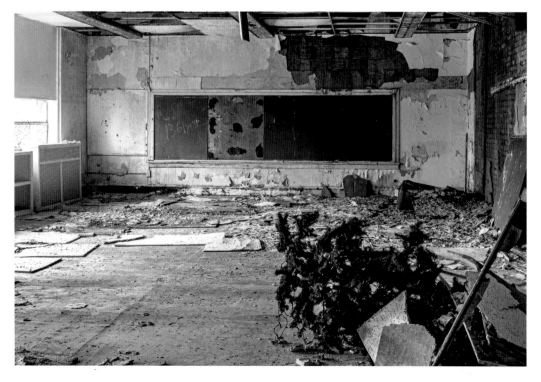

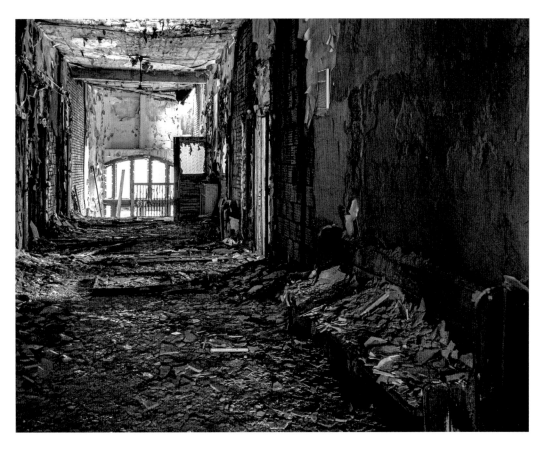

▲ **HALLWAY TO CHURCH AND CLASSROOMS:** While most Americans claim they are Christian, it seems many Sunday church attendees are elderly.

▼ **FRONT ENTRANCE:** Research notes the median age of a church attendee is older than fifty for nearly all mainstream Protestant denominations, and for Catholics, it is forty-nine years old.

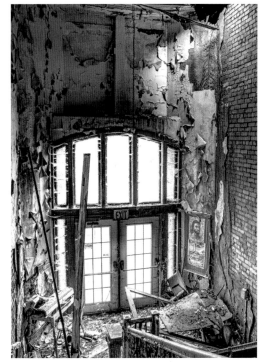

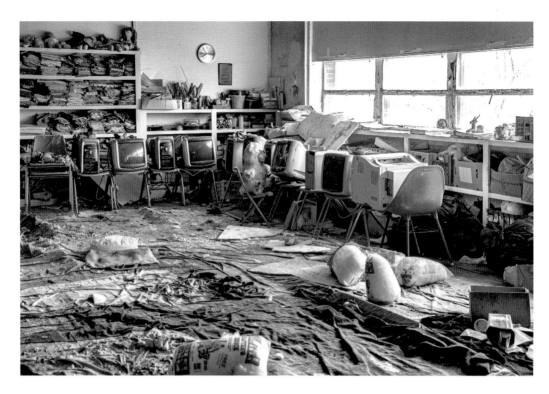

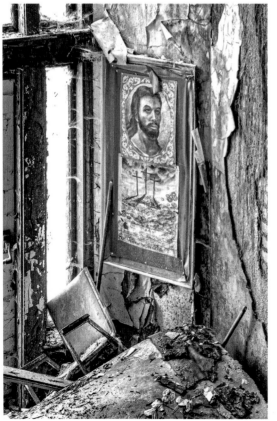

▲ **DERELICT ARTIFACTS AND COMPUTERS:** Nationally, church attendance has been on the decline for decades, but the pace of decline appears to be hastening.

▼ **WALL TAPESTRY AND HEAVED FLOOR AT FRONT ENTRANCE:** The Hartford Institute for Religion Research examined the religious community for three decades, and noted that in the next twenty years, half of the congregations in existence will vanish.

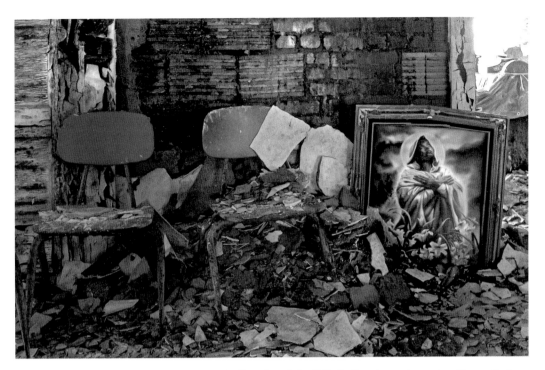

SEATING JUST OUTSIDE CHURCH AREA: Even though the Catholic Church reveals membership growth, there are 2,000 fewer Catholic churches since 1990.

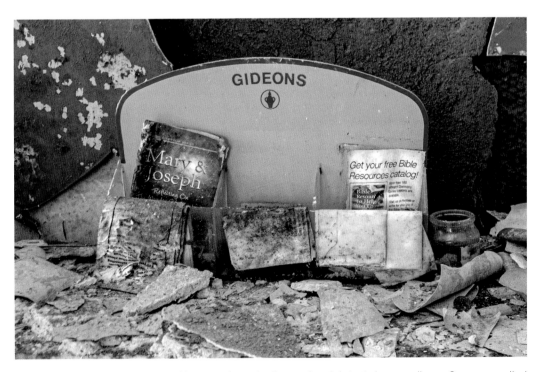

DISCARDED PAMPHLETS: Not every denomination or church is teetering on collapse. Some evangelical denominations and some megachurches reveal growth, but it seems even membership in these congregations are at plateaus.

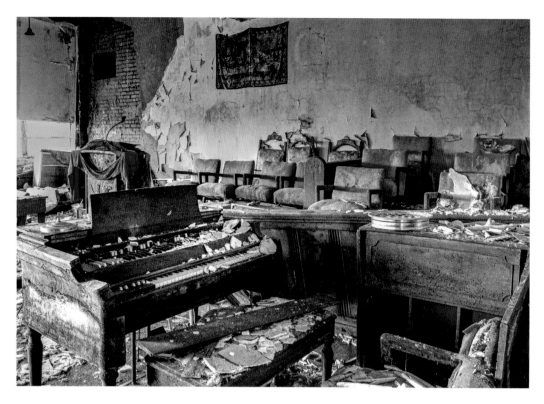

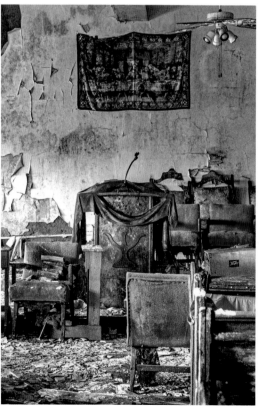

▲ **SANCTUARY PULPIT:** Because the church is such a bedrock of daily life, its absence can leave a spiritual, social, and emotional gap that might be impossible to fill.

▼ **SANCTUARY PULPIT:** The concept of religion is a powerful influence in American culture as it is intertwined in many aspects of life.

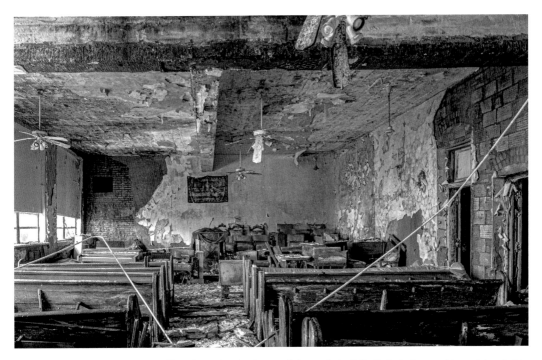

LONG VIEW TO PULPIT: Churches not only play a religious role in daily life but also provide social and civic functions.

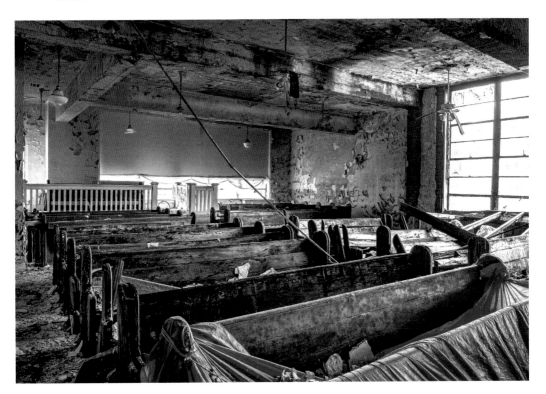

PEWS: When a community loses an engine of economic growth, often neighborhood churches suffer and close due to population flight from the region.

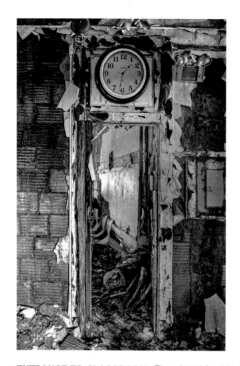 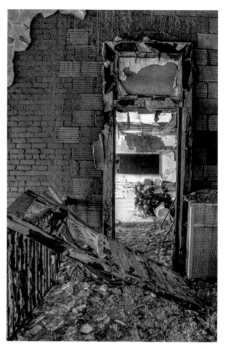

◄ **ENTRANCE TO CLASSROOM:** The church's civic function brings people together and can cultivate trust among individuals and create civic capital.

► **ENTRANCE TO CLASSROOM:** Within the United States, a move from a Christian to post-Christian culture seems to be occurring at an accelerating pace and will soon match the levels of secularization, as found in Europe, Australia, Canada.

CHOIR ROBE: The group claiming no religious affiliation is the largest religious demographic in the United States—larger than evangelicals or Catholics.

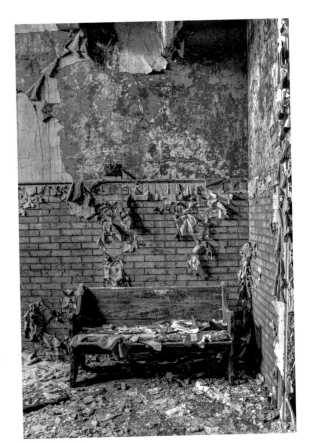

▲ **HALLWAY SEATING:** Because crises often affect church attendance levels, the COVID-19 crisis prompts even committed churchgoers to not attend services and perhaps continue with this habit when the crisis abates.

▼ **KITCHEN:** Future sacred places will rely more on a digital presence as a means of communication.

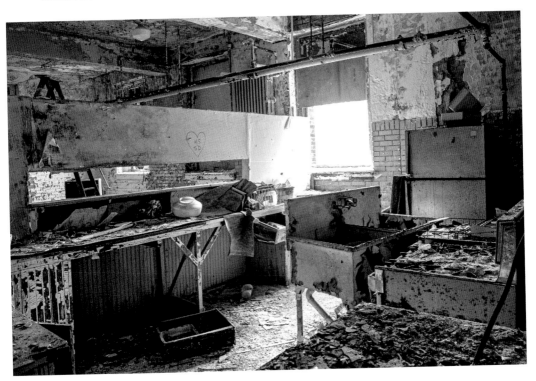

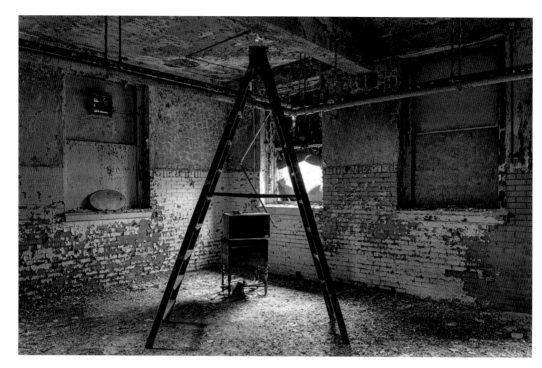

KITCHEN AREA: An unspoken assumption of the traditional church was to expand and have parishioner participation in programs or services. In the future, church leaders might see themselves bringing faith into homes via digital expression.

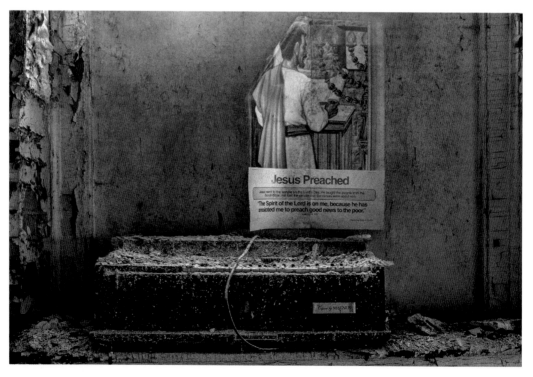

PORTABLE ORGAN: The big box worship center is a baby boomer phenomenon that is waning.

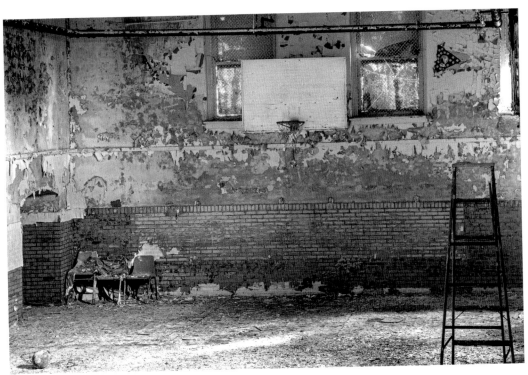

GYMNASIUM: For survival, church facilities might be sharing their buildings and rooms with other organizations, even secular organizations.

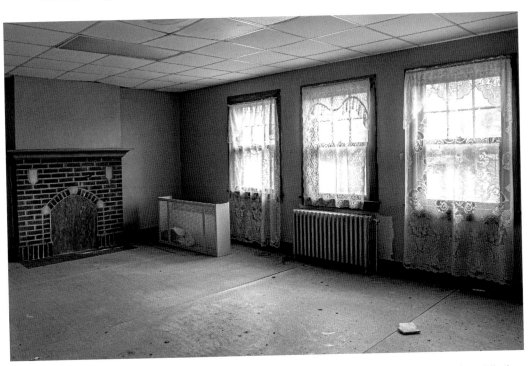

RECTORY: Fewer church staff will be compensated with full-time wages due to declining church contributions and slashed church budgets.

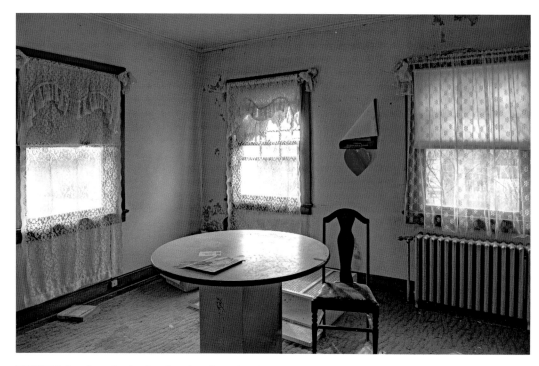

RECTORY: An alternative to attending church services in person is to use the internet for services. In 2020, 60 percent of the world's population will have the internet, and by 2030, it is estimated 90 percent will acquire this utility.

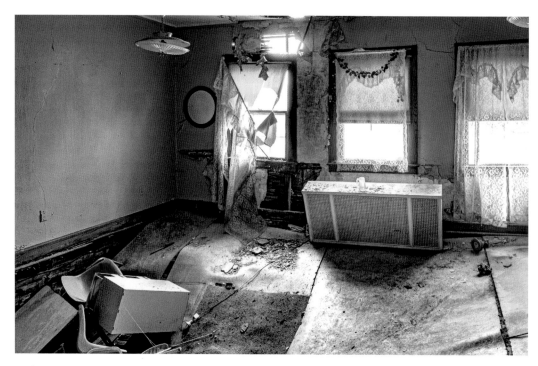

RECTORY DINING ROOM WITH COLLAPSED FLOOR: In America's suffering industrial regions, lean church attendance and monetary contributions highlight this region's changing socio-economic status.

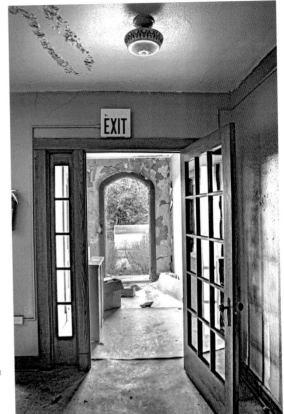

▲ **RECTORY ENTRANCE:** The industrial belts are disproportionately Catholic and often called "Catholic Belts." With so many scandals facing the Catholic dioceses, and the economic collapse of the industrial regions, Catholic churches are gasping for survival.

▼ **RECTORY KITCHEN:** A recent trend in industrial belt Catholicism is the development of the Mass Mob—part of a movement to bring thousands of suburban Catholics to visit struggling or even closed, urban churches and those which their parents and grandparents attended.

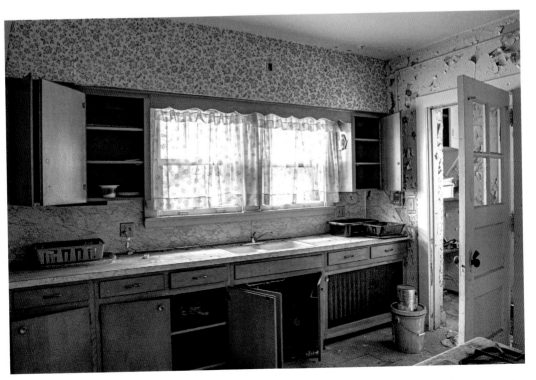

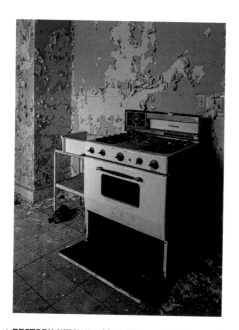
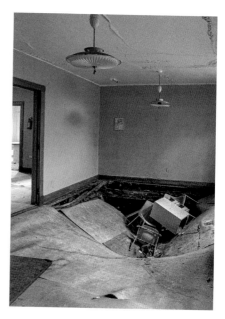

◀ **RECTORY KITCHEN:** Mass Mobs are taking cues from flash mobs in that they are spontaneous gatherings of crowds at a struggling or closed church and often bring forth needed donations.

▶ **RECTORY COLLAPSED FLOOR:** The Mass Mobs attempt to reconnect religious heritage and a generational connection between the older and younger parishioners.

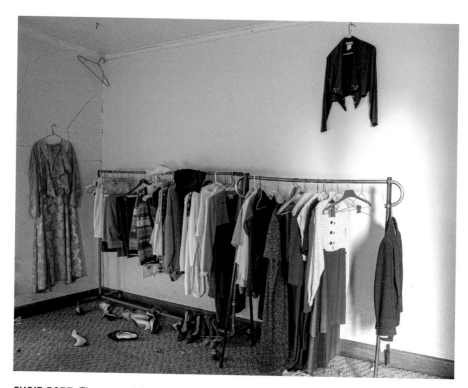

CHOIR ROBE: The group claiming no religious affiliation is the largest religious demographic in the United States—larger than evangelicals or Catholics.

BIBLIOGRAPHY

Charles, F., "The Battle for Rust Belt Catholicism," *City Journal*, 2 April 2019, www.city-journal.org/rust-belt-catholicism.

Swilik, G., "The Variety Theater," History of the West Park Neighborhood, 6 December 2015, www.westparkhistory.com/Articles/Variety/variety.htm.

"Abandoned P&LE Railroad Gateway—Youngstown, Ohio," *Architectural Afterlife*, 19 July 2020, architecturalafterlife.com/2020/07/19/ple/.

Bender, M. C., "Steve Bannon and the Making of an Economic Nationalist," *The Wall Street Journal*, Dow Jones & Company, 14 March 2017, www.wsj.com/articles/steve-bannon-and-the-making-of-an-economic-nationalist-1489516113.

Boak, J., "Trump's Rust Belt Revival Is Fading. Will It Matter in 2020?" AP NEWS, Associated Press, 30 October 2019, apnews.com/d9da6a34207a4da3ad272044a2fd8b53.

Boorstein, M., "For Millions of Americans, No Church on Sunday Is Coronavirus's Cruelest Closure So Far," *The Washington Post*, WP Company, 16 March 2020, www.washingtonpost.com/religion/2020/03/13/millions-americans-no-church-sunday-is-coronaviruss-cruelest-closure-so-far/.

Budds, D., "It's Time to Take Back Third Places," *Curbed*, 31 May 2018, www.curbed.com/2018/5/31/17414768/starbucks-third-place-bathroom-public.

Bures, B., "For the Love of Shawshank," *Vanity Fair*, 25 September 2019, www.vanityfair.com/hollywood/2019/09/for-the-love-of-shawshank.

Cahal, S., "Ohio State Reformatory," *Abandoned*, 20 July 2014, abandonedonline.net/ohio-state-reformatory/.

Carden, U.S. Amb. D. L., "Job Figures Tell the Story—Donald Trump Has Failed to Deliver for Ohio and America: David L. Carden," Cleveland, 23 August 2020,

www.cleveland.com/opinion/2020/08/job-figures-tell-the-story-donald-trump-has-failed-to-deliver-for-ohio-and-america-david-l-carden.html.

CBS News, "The Bannon Interview: Highlights and Excerpts," CBS News, CBS Interactive, 11 September 2017, www.cbsnews.com/news/bannon-interview-highlights-and-excerpts/.

Cherrybomb, "How Motörhead Became the 'Loudest Band in the World' & the Fake Teen Journalist Who Heard It All." DangerousMinds, 2 March 2020, dangerousminds.net/comments/how_motoerhead_became_the_loudest_band_in_the_world_the_fake_teen_journalis.

Crone, J., "Inside Cleveland's Variety Theater Closed 30 Years Ago after Heavy Metal Concert." *Daily Mail* Online, Associated Newspapers, 23 April 2015, www.dailymail.co.uk/news/article-3051950/Bringing-house-Inside-abandoned-iconic-Ohio-theater-closed-30-years-ago-heavy-metal-concert-caused-plaster-fall-ceiling.html.

DeMarco, L., "Cleveland's Historic Variety Theatre Preservation Campaign Gets a Boost (Photos)," Cleveland, 30 May 2017, www.cleveland.com/entertainment/2017/05/clevelands_historic_variety_th.html.

Depalma, A., "The Rise and Fall of Railroads," *The New York Times*, 7 March 1982, www.nytimes.com/1982/03/07/nyregion/the-rise-and-fall-of-the-railroads.html.

Doby, H., A History of the American Movie Palace, February 2013, www.dobywood.com/FoxTheatreAtlanta/Palacehistory.html.

Editorial Staff, "Mansfield Reformatory: Shawshank Redemption Prison, Mansfield, Ohio," RoadsideAmerica.com, 4 October 2020, www.roadsideamerica.com/story/17006.

Editors of Publications International, "Modern Decline of Railroads," HowStuffWorks, 18 April 2008, history.howstuffworks.com/american-history/decline-of-railroads.htm.

Eschner, K., "Movie Palaces Let Everyday Americans Be Royalty," Smithsonian.com, Smithsonian Institution, 12 April 2017, www.smithsonianmag.com/smart-news/movie-palaces-let-everyday-americans-be-royalty-180962824/.

Explores, Mr., "Iron Soup," *Atlas Obscura*, 11 January 2019, www.atlasobscura.com/places/iron-soup.

Fichtenbaum, R., "Column: Has Robust US Economy Benefited Working Ohioans? No: Growth Has Slowed, New Jobs Inferior to Those Lost," *The Columbus Dispatch*, 30 December 2019, www.dispatch.com/opinion/20191230/column-has-robust-us-economy-benefited-working-ohioans-no-growth-has-slowed-new-jobs-inferior-to-those-lost.

Grilli, P., "P&LE RR Gateway Yard," *The Rust Jungle*, 12 March 2017, www.therustjungle.com/rustjungle/2017/3/12/ple-rr-gateway-yard.

Hanauer, A., "Ohio's Economy No Longer Fully Recovers after Recessions," Economic

Policy Institute, 23 March 2019, www.epi.org/blog/ohios-economy-no-longer-fully-recovers-after-recessions/.

Herstad, K., "'The Workingmen's Colony': Labor Conflict and Historic Preservation in Campbell, Ohio," RustBelt Anthro, 3 December 2018, kaeleighherstad.com/2018/10/08/the-workingmens-colony-labor-conflict-and-historic-preservation-in-campbell-ohio/.

Hirsch, M. L., "America's Company Towns, Then and Now," Smithsonian.com, Smithsonian Institution, 4 September 2015, www.smithsonianmag.com/travel/americas-company-towns-then-and-now-180956382/.

"North America's Hump Yards," TrainsMag.com, 8 July 2006, trn.trains.com/railroads/2006/07/north-americas-hump-yards.

Killed, D., *et al*. "Regenerating Youngstown and Mahoning County Through Vacant Property Reclamation," Smart Growth America, February 2009, smartgrowthamerica.org/app/legacy/documents/youngstown-assessment.pdf.

KJP, "Youngstown—A Tale of Two Steel Mills," UrbanOhio.com Forum, 20 April 2012, forum.urbanohio.com/topic/12313-youngstown-a-tale-of-two-steel-mills/.

Kwon, D., "Perspective | The Tragedy to Communities When Church Buildings Are Demolished to Make Condos," *The Washington Post*, WP Company, 29 April 2019, www.washingtonpost.com/news/acts-of-faith/wp/2018/03/28/the-tragedy-to-communities-when-church-buildings-are-demolished-to-make-condos/.

Loh, C. G., "The Road Through the Rust Belt: From Preeminence to Decline to Prosperity; Revitalizing American Cities," *Journal of Urban Affairs*, vol. 38, no. 4, 2016, pp. 602–604., doi:10.1111/juaf.12199.

Matt, "The Variety Theatre," After the Final Curtain, 20 July 2018, afterthefinalcurtain.net/2012/07/06/the-variety-theatre/.

Miller, J., "Inside Cleveland's Historic Hidden Gems," WKYC.com, 6 June 2019, www.wkyc.com/article/news/inside-clevelands-historic-hidden-gems/95-5a4b3132-244f-4368-8dac-93e6f19b8d97.

Montaldo, C., "Mansfield Reformatory: The Most Haunted Facility in Ohio," LiveAbout, 10 March 2019, www.liveabout.com/haunting-ghost-stories-ohio-state-reformatory-972978.

Paulson, M., "At Forlorn Urban Churches, Mass Gets Crowded in a Flash," *The New York Times*, 11 October 2014, www.nytimes.com/2014/10/12/us/at-forlorn-urban-churches-mass-gets-crowded-in-a-flash.html.

Polimédio, C., "Church Attendance and the Decline of Civic Spaces," *Pacific Standard*, 7 November 2017, psmag.com/social-justice/losing-our-religion-and-its-spaces.

Richter, W., "Freight Rail Traffic Is Collapsing," *Business Insider*, 16 October 2016, www.businessinsider.com/us-freight-rail-traffic-is-collapsing-2016-10.

Rickman, W., "On The 40th Anniversary of Youngstown's 'Black Monday," An Oral History," *Belt Magazine*, 20 December 2018, beltmag.com/40th-anniversary-youngstowns-black-monday-oral-history/.

Russo , J., "Fighting the Vacant Property Plague," Newgeography, 21 November 2013, www.newgeography.com/content/004060-fighting-vacant-property-plague.

Schulman, M., The Decline of the Railroads, 2020, www.historycentral.com/railroad/Dewitt.html.

Sciullo, M., "Former Prison in Ohio Draws Captive Audience, Thanks to 'Shawshank Redemption'," *Pittsburgh Post-Gazette*, 19 August 2014, www.post-gazette.com/ae/movies/2014/08/24/Former-Mansfield-reformatory-in-Ohio-draws-captive-audience-thanks-to-Shawshank-Redemption/stories/201408240010.

Sisson, P., "The High Cost of Abandoned Property, and How Cities Can Push Back," *Curbed*, editors, 1 June 2018, www.curbed.com/2018/6/1/17419126/blight-land-bank-vacant-property.

Stine, A., "The Reformatory—Nonfiction by Alison Stine," The Museum of Americana, 19 November 2013, themuseumofamericana.net/issues/current-issue-3/prose/the-reformatory-nonfiction-by-alison-stine/.

Tavernise, S., "Trying to Overcome the Stubborn Blight of Vacancies," *The New York Times*, 20 December 2010, www.nytimes.com/2010/12/20/us/20youngstown.html.

Tucker, C., "Iron Soup' in Campbell, Ohio," 1 January 1970, clancytucker.blogspot.com/2020/05/3-may-2020-iron-soup-in-campbell-ohio.html.

Turner, C., "On Location: Mansfield, Ohio's 'Shawshank' Industry," NPR, 4 August 2011, www.npr.org/2011/08/04/138986482/on-location-mansfield-ohios-shawshank-industry.

"Vacant Properties Plague Struggling U.S. Cities, According to New Report," LILP, Lincoln Institute of Land Policy, 15 May 2018, www.lincolninst.edu/pt-br/news/lincoln-house-blog/vacant-properties-plague-struggling-us-cities-according-new-report.

Virgin, B., "Company Towns Gone—or Are They?" *Seattle Post-Intelligencer*, 21 March 2011, www.seattlepi.com/news/article/Company-towns-gone-or-are-they-1228729.php.

Wolfe, M., "This Place Matters Wrap-Up- Variety Theatre," Two Lanes Blog, 16 July 2018, www.antiquearchaeology.com/blog/this-place-matters-wrap-up-variety-theatre/.

Yglesias, M., "Steve Bannon's 'Economic Nationalism' Is Total Nonsense," *Vox*, 21 August 2017, www.vox.com/policy-and-politics/2017/8/21/16165348/steve-bannon-economic-nationalism.

"Youngstown Sheet & Tube: The First Concrete Pre-Fab Estate in the World," *Architectural Afterlife*, 6 February 2019, architecturalafterlife.com/2018/06/18/youngstown-sheet-tube-the-first-concrete-pre-fab-estate-in-the-world/.

Ziobro, P., "New CSX CEO Shakes Up the Railroad, Starting With 'Hump Yards'," *The Wall Street Journal*, Dow Jones & Company, 18 April 2017, www.wsj.com/articles/railroad-chief-ramps-up-by-closing-ramps-1492531098.

Zito, S., "The Day That Destroyed the Working Class and Sowed the Seeds of Trump," *New York Post*, 18 September 2017, nypost.com/2017/09/16/the-day-that-destroyed-the-working-class-and-sowed-the-seeds-for-trump/.

ABOUT THE AUTHOR

CINDY VASKO was born in Allentown, Pennsylvania, and resides in Arlington, Virginia, near Washington, D.C. For fifteen years, Cindy was the publications manager for a large construction law firm in Northern Virginia, and concurrently, interviewed musicians, wrote articles, and photographed concerts for a music magazine for four years. While Cindy enjoys partaking in all photography genres and is a multi-faceted photographer, she has a passion for abandoned site photography. Cindy is an award-winning photographer with works featured in many gallery exhibitions, including galleries in New York City, Washington D.C., Philadelphia, Pennsylvania, and Paris, France.

Cindy's Abandoned Union series books include: *Abandoned New York*; *Abandoned Maryland: Lost Legacies*; *Abandoned Western Pennsylvania: Separation from a Proud Heritage*; *Abandoned Catskills: Deserted Playgrounds*; *Abandoned Southern New Jersey: A Bounty of Oddities*; *Abandoned Northern New Jersey: Homage to Lost Dreams*; *Abandoned West Virginia: Crumbling Vignettes*; *Abandoned Washington, D.C.: Evanescent Chronicles*; and, coming soon, *Abandoned Eastern Pennsylvania: Remnants of History*; *Abandoned Northern Virginia: Desolate Beauty*; *Abandoned Southern Virginia: Reckless Surrender*; and *Abandoned Salton Sea, California: Dystopian Panoramas*.